This book is due for return on or before the last date shown below.

Don Gresswell Ltd., London, N.21 Cat. No. 1208

DG 02242 / 71

BRITISH LANDSCAPE PAINTING

PHAIDON · OXFORD

Michael Rosenthal

BRITISH
LANDSCAPE PAINTING

Phaidon Press Limited, Littlegate House,
St Ebbe's Street, Oxford

First published 1982
© 1982 by Phaidon Press Limited

British Library Cataloguing in Publication Data
Rosenthal, Michael
 British landscape painting.
 1. Landscape painting, English
 I. Title
 758′.1′0942 ND 1354
 ISBN 0-7148-2198-5

Printed in Singapore under co-ordination by
Graphic Consultants International Private Limited

Contents

Preface

To paint a landscape a painter must study and, to an extent, understand the subject. Those who study landscape paintings should have something of the same understanding. Today this must be increasingly rare. Far fewer people than at any other time lead lives involving landscape (in the form of the countryside) directly, and because of their repetition and spread through photography, cinema and television, landscape images almost lose individual identity.

Our current detachment from the rural environment is unprecedented, and it can be hard to comprehend to what extent landscape was inescapable before the great town-building boom of the nineteenth century. Today, when most people live in towns or cities and buy their food neatly packaged in hygienic plastic from supermarkets, there is no need to think of where the meat or vegetables originated. The contemporary dissociation of the urban population from the landscape and its products is perhaps encapsulated in the famous story of a Second World War evacuee failing to recognize a cow, and being startled to discover that this was the source for his milk. There is a paradox to this, for never has landscape been so accessible. Many Britons travel, not only through the domestic landscape, but also to such recently inaccessible places as Greece or North Africa, usually anaesthetized of their strangeness by the careful ministrations of professional couriers. Likewise, bus tours through the British countryside do not set out with the aim of appreciating landscape, but rather with traversing it to reach some place of interest, and it features only as a series of motifs, framed through the coach windows, giving or not giving pleasure as attention is directed to it.

While the 'simple country life' retains a curiously strong appeal, the proportion of country-dwellers is now far smaller than before the 1830s. One reason for this is economic. The Industrial Revolution, which by then was at full steam, lead to massive urban development as population migrated and increased to cope with the labour demands of the factories. And as the new cities grew, the monopoly of wealth moved away from firmly entrenched landowners (who, however, continued to hold disproportionate political power) to a new class of enterprising bourgeois not guided by centuries of tradition as to how to dispose of its money; something to which much Victorian painting offers grim testimony.

Prior to the early nineteenth century Britain was pre-eminently an agricultural country. What was not forest or waste was cultivated, and most people were in some way directly connected with agriculture; from the farrier to the absentee landlord, who relied on the rents from his country holdings to finance his extravagances. Towns were smaller than today, and the basis of prosperity and power was the country estate.

If 1837 is taken as a convenient, albeit

crude, date for the break between the old and new relation to landscape, certain differences may be observed. Before the reign of Queen Victoria, travel was slow, and, as Ibbetson shows, uncomfortable (*Plate 44*). The railway boom made it faster and more convenient, and the very fact of speed altered the ways in which landscape would be perceived (*Plate 119*): people were sealed from direct contact with the environment, and could pass from town to town without noticing it. Many lost a sense of the reality of the countryside, did not know that it offered more inconveniences than facilities, that it could be hostile, that, on a simple level, the country in March, deep in mud, and cold, is not an amenable place, although from the train it might present a series of pleasing pictures. It is important to note this detachment, which has persisted and grown stronger.

The countryman develops a sense of landscape in time and in all moods, whereas today for the urban dweller it is a place of recreation (*Plates 163 and 166*), to be taken or left at will. Certain myths persist, notably that the country life is morally purer and generally preferable to the city one, which since the nineteenth century has taken on a new convenience. The modern caravanner takes with him a television and a refrigerator, lives in the midst of nature, but emerges into it only when the sun is shining, and is exposed to it only for a prescribed time (*Plate 166*). The poet Cowper wrote *The Task* while actually living the life of rural retirement and moral self-improvement it describes. Today we can go to a Suffolk pub and agree with the message of its beermats (*Plate 176*), which, we shall see, make their point by referring to traditional rustic imagery, and then get on the train back to London.

I have been trying to outline a change in habits of perceiving landscapes from one affected by knowledge of and economic dependence on their products (so that the glad sight of a cornfield is glad on grounds other than its just looking good) to one which is momentary and calculated, and makes few demands of understanding. The difference can be seen by contrasting the problems Nebot had around 1740-50 when attempting the wild and picturesque landscape of *Aysgarth Falls (Plate 45)* with Landseer's justly famous appropriation of sublime Highland scenery and its fauna in 1851 in *The Monarch of the Glen (Plate 141)*, a painting of such popular appeal that it has been used to advertise whisky. Even though hikers still die regularly in the mountains, by the mid nineteenth century terrain like this presented no threat, and the stag, far from being presented mainly as venison on the hoof, becomes an image of nobility, so anthropomorphized that we have to see it as embodying the sorts of virtues more logically attributed to humans. Nebot had been far less at home in wild scenery, and just how extraordinary Landseer's vision of the Highlands is needs stressing. Seventy years before the picture was painted, most people avoided landscapes like this, although a taste for them was developing.

When, in the late eighteenth century Gilpin had visited Dovedale, he had found it 'chaste, and picturesquely beautiful in a high degree'. Just over a hundred years before, Charles Cotton had written *The Wonders of the Peake* as a vehicle for lauding the beauties of Chatsworth, and flattering its inhabitants. He had found the same landscape:

A Country so deform'd the *Traveller*
Would swear those parts Natures *pudenda*
 were:

There is much the same difference between Nebot struggling to get to grips with the picturesque beauties of Aysgarth Falls and Landseer facing no such problems in the Highlands. One of the themes I hope to describe is how a taste for the wilder scenes of nature, once it had grown up in the eighteenth century, stayed fairly constant, although the

ways in which such landscapes were perceived developed and varied. As its counterpart, I should like to survey the ways artists have dealt with agriculture in landscape. This is partly because a Roman tradition of the Labours of the Months resurfaced in the Middle Ages; (it uses harvesting, say, to indicate the summer, or pruning the spring, which tends to incorporate landscape elements) and can be seen to have persisted into the twentieth century. And because the agricultural landscape has often been seen as the antithesis to wild scenery, and has been found preferable, it is interesting to trace its development.

Before the Industrial Revolution most of the population lived in the countryside and had contact with and an understanding of it. Until around 1760 the general reaction to uncultivated landscape was distaste. It was preferred cultivated, because farming rendered it ordered and intelligible, made it into patterns of fields and tracks intimately connected with the village and the great house for the benefit of which the ground was farmed. A harvest landscape is more pleasurable to see than a rocky gorge, for the latter is dangerous even to negotiate, and humanity makes little impression. Or at least this was the common opinion until the later eighteenth century, perhaps difficult to understand today, when the chief threats posed by the countryside are stinging insects, nettles, and agricultural chemicals. This essential distrust of landscape is apparent for instance in the medieval Gough Map, where pictograms denoted roads or habitations only. It gave essential information, on where people lived, or how one might get from one group of them to another, but revealed no concern with the countryside. Today we can study a $2\frac{1}{2}$ inch Ordnance Survey map and deduce from its sophisticated codes not only the morphology of terrain, but also whether it has pine or deciduous woods; or fields, or whatever. In the

Middle Ages such things were irrelevant. Although fields were cleared from woodland by assarting (grubbing up trees and bushes), it is significant that the *outlaw* Robin Hood lived deep in Sherwood Forest: the anarchic locality suited the social position of its inhabitants. Civilized and law-abiding citizens lived in villages and towns.

In this book I shall consider the ways in which people have reacted to the countryside, and in particular how these can be observed in landscape painting. This is intended to provide some record of attitudes to both cultivated and uncultivated scenery, essentially from the seventeenth century onwards. This is a thematic approach, and I have avoided such things as biographical data on the grounds that they would not be strictly relevant to the lines of discussion.

I have been able to draw on the work of distinguished scholars, some of whom are mentioned in the text, and others in the bibliography. The impossibility of citing them all does not lessen my awareness of my obligation to them. My interest in landscape painting was awakened by Terence Doherty and encouraged by Michael Kitson. At Warwick University I have taught various courses on the subject, and have had several pupils who taught me much. I have benefited from the conversation and advice of Malcolm Cormack and John Barrell, and have learned from the researches and conversation of Anthea Callen, Duncan Bull, and Hilary Watson. I have leaned heavily on many friends' willingness to help out with information and opinions, and am particularly grateful to Ben Read, Rosemary Treble, Pete Nicholls, and Paul Hills. And I should like to extend heartfelt thanks to Amanda Simpson, Anthony Macfarlane, and Louise Campbell, who read parts of the first draft and made valuable suggestions. Lastly I should like to thank my wife for her patience and encouragement.

1 The Middle Ages to the Restoration

British landscape painting is a product of the Restoration. It did, however, have medieval origins, and I should like briefly to mention these, and to discuss certain trends in sixteenth- and seventeenth-century painting as an introduction to later work.

Medieval British painting gives an impression of an interest in the landscape only insofar as it was impossible to avoid it completely. This is strongest in terms of the agricultural scenes which on Calendars marked the progress of the year in the form of the Labours of the Months. Nevertheless, by the fourteenth century some interest in the world outside was clearly being taken.

The Luttrell Psalter of 1340 (*Plates 1 and 2*) is an East Anglian manuscript with charming and precise illuminations; the charm residing in the closely observed details of familiar flora and fauna. The agricultural scenes have their prototypes in calendars (where for example pruning would signify March and harvest August) but are here divorced from that context. Rather than repeat standard pictograms, the painter appears to have looked at what went on in the fields. That plough is obviously an actual type; short-handled, with a long mouldboard, and pulled by four oxen in pairs. Likewise when the peasant goes harrowing a rope sling is used to fire stones at closely observed crows, while the harrow has been shown with obvious care: details which seem to reflect genuine pleasure in everyday life, and an engagement with actuality. Landscape as such hardly exists, appearing as a stretch of ground, but this artist did fulfil one of the prime criteria for landscape painting by transcribing what there is to be seen in landscape, although there is a tension between the landscape interest shown by the margins of oak leaves and its denial in the summary setting given to the figures. During the fourteenth century, largely under the impulse of developments in the Low Countries, agricultural incidents, particularly in the form of the Labours of the Months, were gradually located, and so agricultural landscape painting began to develop.

This happened spectacularly with Pol and Jean de Limbourg's *Les Très Riches Heures du Duc de Berri* (begun in 1413) and its famous calendar, in which the labours take place in fields in front of recognizable buildings and form an integral part of actual scenery. Painters like Van Eyck (and his successors) helped develop the art of landscape, and by the early sixteenth century the traditional labours comprised only part of sensitively observed agricultural landscapes, particularly in Flanders (*Plate 4*). Contemporary British work shows that things were less highly developed (*Plate 3*) here.

Indeed the arts did not flourish under Henry VIII, and the Reformation effectively did away with vitally important Church patronage. Britain became culturally isolated, and from our point of view there is nothing much to remark

1
Ploughing. From the Luttrell Psalter. *c.* 1340. London, British Library

2
Harrowing. From the Luttrell Psalter. *c.* 1340. London, British Library

tatis : qui fingis laborem in precepto.

Captabunt in animam iusti : ꝗ san

guinem innocentem condempnabūt.

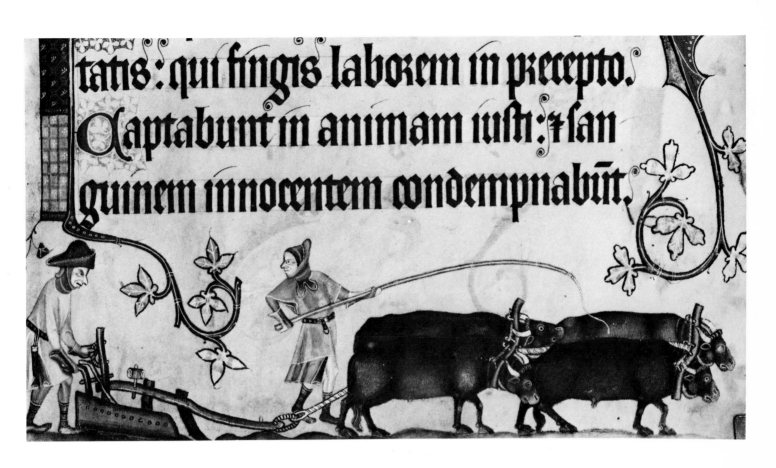

e obdurare corda uestra

ſicut in irritacione : secundum die

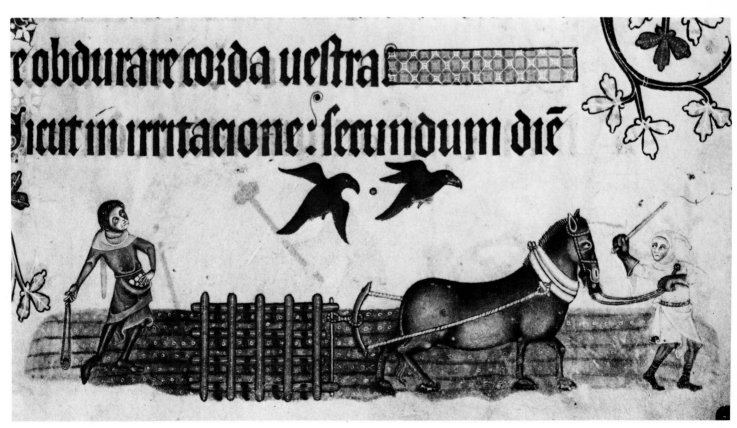

until into the seventeenth century. True, there was some good painting in Tudor Britain, the works of Holbein are ample evidence of that. But an interest in landscape can hardly be traced. We know that certain conventions persisted in literature, particularly the Labours of the Months, which turn up in Thomas Tusser's *Five Hundreth Poyntes of Good Hosbondrye* (1573), where certain descriptions are certainly graphic, if not pictorial. An example is haymaking in July:

With tossing and raking, and setting on
 cocks,
Grass lately in swathes, is hay for an ox:
That done, go and cart it, and have it away,
The battle is fought, ye have gotten the day.

Imagery like this may be found not only in manuscript illumination, but also in agricultural landscape painting into the nineteenth century: one of the fascinations of the artistic treatment of unvarying motifs is that by definition points of contact have to be sustained. Until it became mechanized the details of haymaking did not alter much from one year to the next.

In Flanders the Labours of the Months had in 1565 been confirmed as true landscape painting by Peter Bruegel (*Plate 5*). Flemish artists working in the tradition he founded were to be important to British developments, and his imagery was widely transmitted through prints, which, the Ogdens tell us, found their way to Britain early on. Despite Bruegel's *Harvesters* being as famous as Constable's *Hay Wain* and therefore in danger of being so familiar that no one looks at it, it is still worth considering the details of the landscape. Bruegel has surveyed his scene from a high viewpoint, with a cornfield in the foreground. In front of this labourers are at work with their sickles, and sheaves are carried down a track through the fields to carts, which then transport their loads to barns in a village. Beneath a tree a group of peasants is splayed, exhausted by labour and heat. Bruegel has taken up tra-

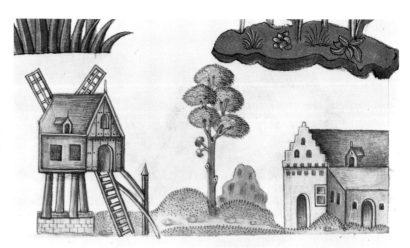

ditional elements from manuscript illumination and has transferred them to a landscape painting which emphasizes not only the logic of the terrain (insofar as this is a feasible, albeit probably invented, combination of hills and plain) but also the logic of the activity: the cutting and transporting of corn is continued throughout the landscape. An element of explanation, amounting sometimes to the near-diagrammatic seems to persist in agricultural landscape: it is not unrewarding to compare this Bruegel with Stubbs's *Reapers* (*Plate 86*) of 1795, particularly in the way reaping itself has been shown.

Landscape must have been recognized as a genre of painting by 1593 because the word 'Landschap' was in Dutch by then. In Britain however it seems not to have been held in high regard. Hilliard of course enjoyed placing his languid aristocrats against a naturalistic background, but whether this constitutes 'landscape' is open to debate, and the portrait miniature cannot claim to be the most elevating genre. Henry Peacham in his 1612 *Graphice* — an enlargement of the 1606 *Art of Drawing with the Pen and Limning with Watercolours* — stated that 'Lantskip' was a word taken over from the Dutch, and defined it as 'expressing of the land by woodes, Castles, seas, valleys, ruines,

3
Windmill from Pattern Book. c. 1520-30. Oxford, Bodleian Library

4
Calendar illumination for August. From a Flemish manuscript. Early sixteenth century. London, British Library

hanging rocks, Citties, Townes, &c. as farre as may be shewed within our Horizon', to leave little scope for error. He also added that landscape was normally used only as a backdrop to the more important scenes placed in front it.

This was not so in the rest of Europe. Continental developments in landscape painting during the seventeenth century are of great interest, but only Flemish painting is directly relevant to Britain. A weary Rubens took to landscape in the 1630s, late in his life when he retired to a country life at Steen, a life he celebrated in several paintings, but most particularly in his *Landscape with the Château de Steen* (*Plate 6*). The painting anticipates trends important in Britain later in the seventeenth century, and moreover establishes an iconography of landscape, which, after the Restoration in 1660, was of major importance. While Bruegel was careful and precise in his style, Rubens liked to demonstrate his virtuosity in oil paint. And while he derives his 'plateau' composition from Bruegel, he lets it spread; on the right to an expansive and lush plain, and on the left along a track to the Château de Steen itself.

Rubens's painting is a celebration of various aspects of an accepted idea of the Country Life. While the Château far in the left background is inconspicuous, it is of great importance as a focus and explanation for all that bursts out around it. The landscape itself comprises a vast extent of wood and meadow, golden in light, with herds grazing contentedly. In the left foreground is a market-cart carrying both produce and a rubicund rustic female, moving down a track away from the castle. Nearby a hunter and dog are about to astonish some sleepy ducks. Looking more closely at the castle itself, we see the immediate grounds populated by well-dressed characters promenading. Although the main point of the picture is the lavish profusion of nature, these carefully placed figures do give it a more directed reason. As the

landscape bursts out from the Château, so does it stand at the core of all we see. And all we see is abundance, recreation, and rural sports.

Rubens encapsulates visually the idea of a country life in which the estate is fruitful enough to send spare produce to market, where nature gives up its treasures willingly, and where one has the added pleasure of rural sports like duck-shooting. And he does this self-consciously. Rubens enthusiastically espoused habits of thought developed from that fifteenth-century Italian upsurge of interest in Antiquity, and ideas of country living expressed by Roman authors affect his conception here. First there is the notion stated by Horace as 'Beatus ille': the 'happy man', who lives on an ancestral country estate and is both materially self-sufficient and philosophically content. This retirement contrasts favourably with the morally destructive whirl of towns. It is an ideal which strongly influenced British literature and created the moral structure for a poem like Ben Jonson's *To Penshurst*, which is of the same era as the *Château de Steen*. The element of morality in this idea of country life cannot be too strongly stressed, for living on one's own estate, like Cincinnatus tilling the soil, immunizes one to the artificiality of urban courtly life, with its excesses and lack of balance. Rubens of course had himself been a courtier, and by retiring to Steen was living out a mainly literary idea.

It was not exclusive to Horace. Virgil had taken it up too, in *The Georgics*:

O happy, if he knew his happy state!
The swain, who, free from business and debate,
Receives his easy food from Nature's hand,
And just returns of cultivated land!

And of himself he wrote:

My next desire is, void of care and strife,
To lead a soft, secure, inglorious life,

(Dryden's translation)

5
PIETER BRUEGEL THE ELDER: *Harvesters*. 1565. Oil on wood. New York, Metropolitan Museum of Art

6
PETER PAUL RUBENS: *Landscape with the Château de Steen*. After 1635. Oil on panel. London, National Gallery

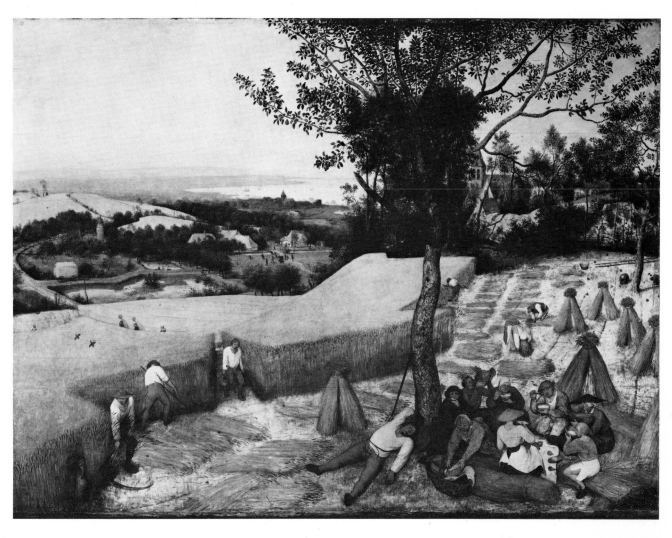

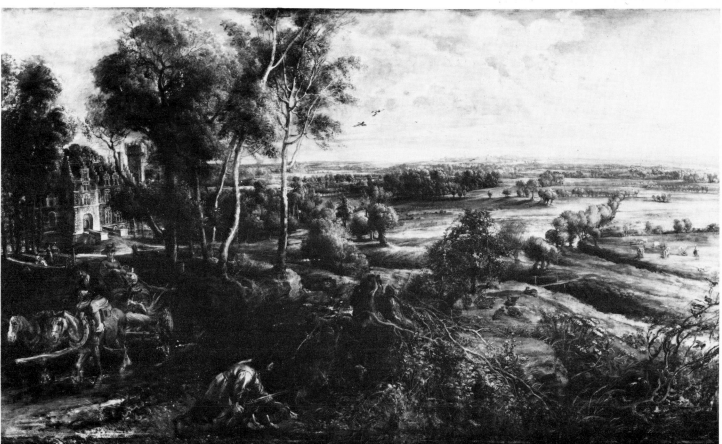

He thus associates himself with this ideal of rural retirement. Although this classical literary ideology is not without its complexities, a simplified account of what it involves is necessary. First, the town is opposed to the country on the implicit assumption that life in the latter is morally superior to anything the town has to offer: there are fewer temptations, work is more immediately useful, the community is more organic, and so on. *The Georgics* themselves introduce a further slant to this unexceptionable doctrine. The poem was written to celebrate the end of the Roman Civil Wars and to encourage Augustus to good government. It does this by functioning as an agricultural text-book in four sections, dealing with agriculture, viniculture, animal husbandry, and bee-keeping, in so much detail that it deliberately reads as practical instruction. In this respect it was meant to supply the needs of those newly settled ex-soldiers, who had no previous experience of farming. Virgil's motives, however, were less simple, and he does infuse a moral character into his teaching. Efficient agriculture feeds a nation, allows it to carry out civic works, and gives it the time (for not all can farm) to become culturally developed in terms of literature, music, or the visual arts. This is the domestic side to national superiority, which may otherwise be represented in terms of military might (or the protection of one's boundaries).

Nations less civilized than the Romans spent more time scratching their subsistence from the ground, and their achievements are proportionately less impressive. If the peaceful and civilized landscape is, as Virgil tells us, the cultivated one, the converse, the desolation of the battlefield or of nature uncultivated, signifies a society of little moral fibre, of bestial ideals. The idea was that man had first eaten acorns along with his pigs, then the pigs themselves, had gone on to adopt a pastoral existence, and finally, by inventing the plough, had

learned to cultivate the soil and had begun to form settled communities. The advance is clear. Virgil wrote too within a philosophic framework in which Man had fallen from a Golden Age, and it was only through hard work that he could claw his way back to this perfection. Clearly such a thing is desirable, and therefore if the community has a settled rural base and indulges neither excess nor debauchery, then civilization can progress: there is time for the creation of art or literature. Hence the look of a landscape reveals the society which inhabits it. A cultivated one denotes civilization, but because a wild one indicates a more savage population, the onus is always to maintain the development of agriculture.

These ideas are relevant to British cultural history, at least up to the early nineteenth century. The classical authors were thought of as proper models for modern writing, and from 1700 their sentiments and their poetic forms were thought so fitting to modern life that they were appropriated. Numbers of English georgics were written from then on, and poems like Thomson's *Seasons* are based on a georgic interpretation of landscape. Virgil, and to a lesser extent Horace, formulated ways of making sense of, evaluating, what was to be seen in the countryside. If a harvest plays a georgic role in a landscape painting this is because it

7
ANTHONY VAN DYCK:
Landscape Study.
c. 1635. Watercolour and body colour on grey paper. London, British Museum

8
ANTHONY VAN DYCK:
Charles I of England.
*c.*1635. Oil on canvas. Paris, Musée du Louvre

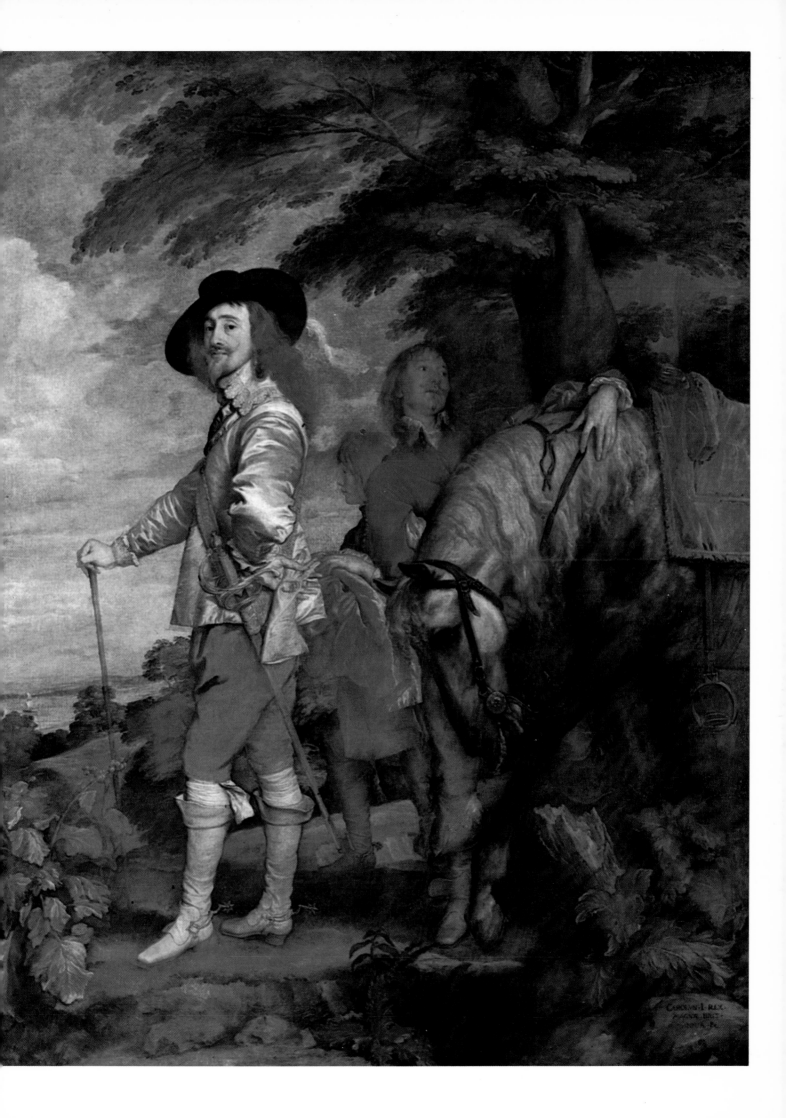

implies the fundamental cultural worth of agriculture, the plenty and wealth attendant upon cultivation.

Therefore a landscape's appearance owes much to the calibre of the society which inhabits it. The peace and plenty which, with Rubens, we can survey around Steen is definably georgic (a point about Renaissance thought being that it took antique ideology as applying to reality) and the painting thereby gains a moral dimension. Or at least it does for Rubens. We should not look too closely into his biography, or question his pretensions as he signifies his social respectability by the purchase of the country estate, and compared with the peasants Bruegel showed, Rubens's rustics seem a little idealized. However, the georgic idea of country life which informs this painting is passed on to other Flemish painters, and through them to British art at a time when its patrons were particularly attuned to antique ideals.

This did not happen for a while, though, and to judge from the isolated instances of landscape in Britain before the Restoration, the interest was in topography. Van Dyck produced lovely watercolours of British landscapes (*Plate 7*) but when he pictured Charles I (*Plate 8*) it was in a generalized rather than a particularized locale; that is, he was using landscape in the way that Peacham had written, as a backdrop. When Rubens wanted to compliment the same monarch he had him as St George rescuing numerous plump maidens along the banks of the Thames, with Windsor Castle in the background (*Plates 10a and b*). Although undeniably in a topographically recognizable landscape, the castle is there not as a study in antiquarian architecture, but as the means of locating 'St George', and therefore making a rather heavy-handed and typically Baroque compliment to the patron.

Contemporary with these works are those in which topography features for its souvenir value rather than anything else. Kierinx's *Richmond Castle, Yorkshire* (*Plate 9*) is a straightforward view across to the town, and Hollar's

9
ALEXANDER KIERINX:
Richmond Castle, Yorkshire. 1638-40.
Oil on panel. New Haven, Yale Center for British Art, Paul Mellon Collection

10a
PETER PAUL RUBENS:
Landscape with St George and the Dragon. c. 1630. Oil on canvas. Reproduced by Gracious Permission of Her Majesty the Queen

10b
Detail of Plate 10a

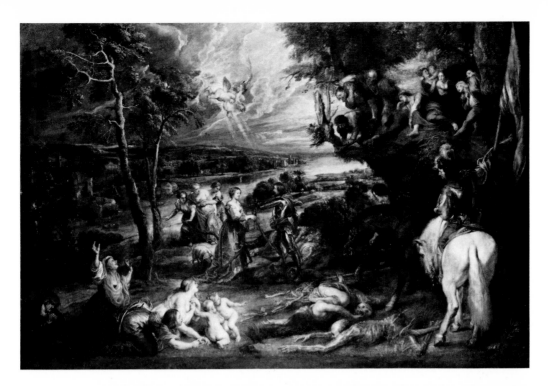

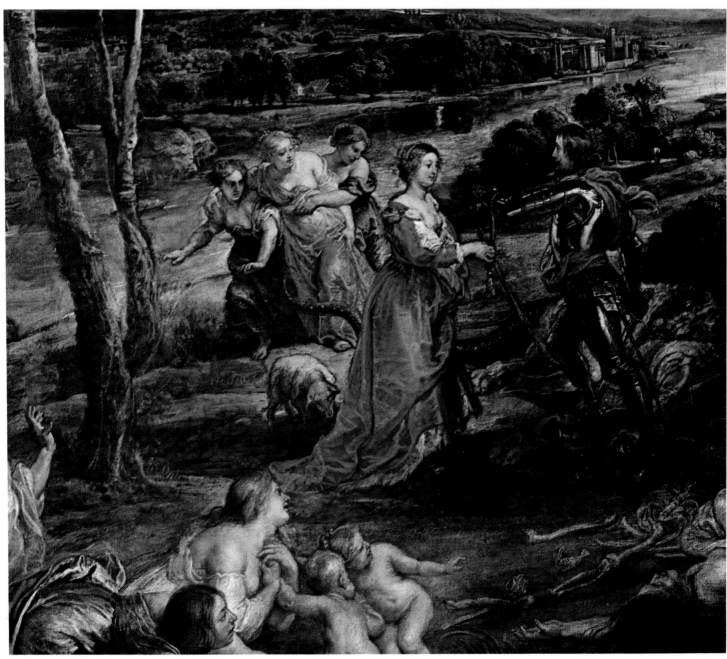

11
WENCESLAUS HOLLAR:
*View near Albury,
Surrey.* 1645.
Engraving. London,
British Museum

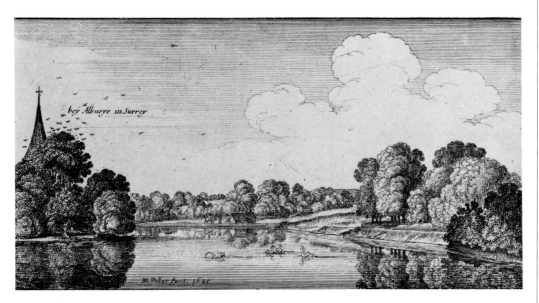

12
WENCESLAUS HOLLAR:
*View near Albury,
Surrey.* 1645. En-
graving. London,
British Museum

engravings of British locations (*Plates 11 and 12*) serve the same function with exceptional skill. But these are not landscapes with many pretensions, and the fact that they were done by visiting foreign artists (native-born ones only begin coming into their own in the later seventeenth century) is worth noting. It does not suggest any great native enthusiasm either for art or for landscape painting, and if there was any pre-Restoration demand for the latter it was for such topographical pieces. However, after 1660 landscape painting does begin to develop, and this will be examined in the next chapter.

2 Prospects and Landscapes

In 1660 the Restoration of the monarchy and renewal of comparative social stability helped create an atmosphere in which the arts could develop steadily. Under the influence of Wren, architecture flowered into a distinguished insular version of continental Baroque, and between 1660 and the accession of George I in 1714 not only were great buildings, like St Paul's Cathedral, erected, but also architects like Talman at Chatsworth, Hawksmoor at Easton Neston, and Vanbrugh at Blenheim created superb domestic architecture for a supremely self-confident ruling class. With the ending of the Civil War a group of powerful peers asserted itself culturally through patronage, for instance the Duke of Devonshire's rebuilding at Chatsworth. New wealth was also being created. Daniel Finch, 2nd Earl of Nottingham, made his fortune through trade, law, government office, and two prudent marriages, and then sank it in the building of Burley-on-Hill, and such activity was just one sign of an awakening interest in the Arts.

In painting, the years 1660-1755 saw important changes. Despite the interest of the aristocracy in literature and the theatre (we need only think of the poetry of Dryden or of Restoration drama in general), when it came to the visual arts they were, and have remained, philistine: Kneller's domination of portraiture from the late seventeenth century onwards is eloquent testimony to this. But it shows up too in landscape painting, for as a nobleman employed decorative painters to embellish the interiors of his mansions, and portraitists to depict himself or his family, so the chief form of landscape painting from 1660 is the Prospect (*Plates 13-16*), also a kind of portrait, but featuring the great houses and their surroundings. Knyff for instance put an identifying inscription in the corner of his painting of Hampton Court (*Plate 14*), just as other artists wrote the name of the sitter on more conventional portraits. As a glance at these Prospects will show, they had few aspirations to high art but were concerned with making a detailed record of appearance. A general interest in data of this kind appears to have grown up. Kyp's engravings after Knyff's Prospects for a book, *Britannia Illustrata* (1707), proves that by this time there was a market for such images. The traditional interest in topography was maintained, but a genre of landscape was set aside for it, one which will be seen to reveal something of its patrons' attitudes to country living.

Under the Stuarts the Prospect was practically the only kind of landscape painting, but as more people gained money, and trade expanded, the arts responded by developing themselves. This means that the story from 1710 onwards is rather more complex. Pure landscape begins to appear, at the same time as influential writers like Pope and Addison were expressing a taste for the countryside and for gardening. We shall see too

that from the late 1720s, primarily thanks to the drive of William Hogarth, painting altogether improved and diversified. Before Hogarth we think of British painting being done mainly by foreign artists, after the late 1720s an increasing number of British ones appears on the scene. At this time too, landscape, now established, began to appear in different guises, and, after considering the Prospects, and the agricultural landscape paintings to which they gave rise, I shall end this chapter with a survey of some of the other types of landscape painting developed around the 1720s.

As the Stuart ruling classes liked to perpetuate their own images in portrait, they also liked to see pictorial descriptions of their houses and estates, the Prospects. It is a species of landscape often in the form of a bird's eye view, and one that was usually painted in a scrupulously descriptive style. The convention did not develop much. *Llannerch, Denbighshire (Plate 13)* is one of the first Prospects. The painter has not only surveyed the house, but also included St Asaph's cathedral in the view. John Harris has said that one of the picture's functions was to commemorate the recently laid out grounds; besides doing this it describes the integration of the house and grounds within its landscape, maps the domains. In a similar way Knyff made a record of the appearance of Hampton Court *(Plate 14)*, which I should now like to consider, along with another Prospect, of *Bifrons Park (Plate 15)*.

In these paintings the house, usually through the simple device of being put in the middle of the composition, comes over as the 'centre' of the particular small universe in which it is sited. The long avenues radiating out from Hampton Court are a pictorial metaphor for the social reality of the influence and power which centred on the great house itself. To study either this painting or the one of Bifrons Park closely is an intriguing exercise. At Hampton Court such useful parts of the estate as the kitchen gardens and the farm buildings are incorporated into the geometry of the architecture and formal gardens and are thus seen as integral to the whole, devices like the avenues and the canal mediating visually between the intellectual control of the landscape about the house and the more random appearance of the rest. To the seventeenth-century mind this would have indicated the benign effect the house had over its estates, and Knyff seems even to have employed a colour coding to point this up. The immediate surrounds of the house are green and therefore fertile, the ground beyond touched with yellow to show perhaps that it wants the hand of improvement. Likewise the artist (probably Siberechts) who painted Bifrons Park in the 1700s could vary the conventions because the landscape was so obviously cultivated and inhabited. Here for example the walled garden divides the aesthetic geometry of the house and the practical one of the enclosures. Where green is contrasted with yellow, the latter now stands for cornfields, which, along with such things as the haycocks in the near distance, demonstrate the beneficial effect the community has on the landscape. A social divide is however intimated between the gentry, indulging the rural sport of hawking, and the proletariat, who are at work and are taken for granted. The character rolling the turf paths in the garden goes unnoticed by those who use the same ground for cultivated leisure. The juxtaposition of images encapsulates their differing relationship to the landscape, while pointing to their common dependence on the house.

Indeed these paintings seem retrospectively to connect with a species of country house poem which flourished particularly in the years before the Civil War, and of which examples are Jonson's *To Penshurst*, Carew's *To Saxham*, and

13
Llannerch, Denbighshire. c. 1662-72. Oil on canvas. Artist unknown. New Haven, Yale Center for British Art, Paul Mellon Collection

14
LEONARD KNYFF: *South-East Prospect of Hampton Court, Herefordshire.* 1699. Oil on canvas. New Haven, Yale Center for British Art, Paul Mellon Collection

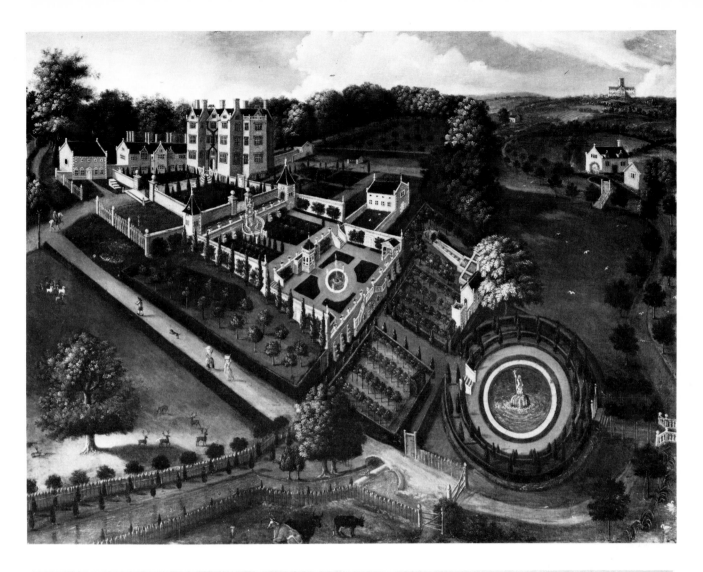

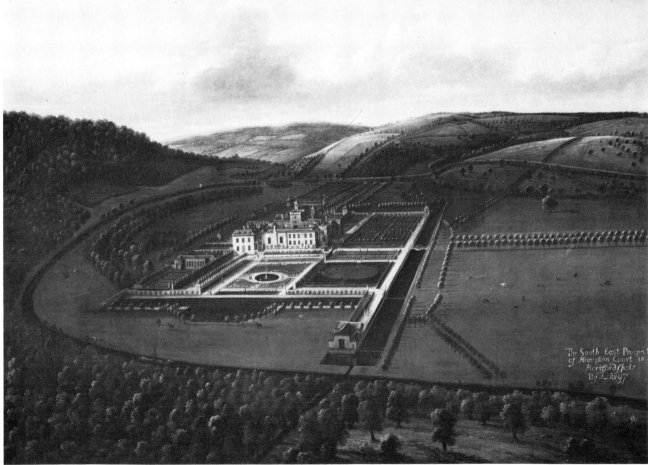

The South East Prospect
of Hampton Court in
Herefordshire
By L Roff

Herrick's *Panegyric to Sir Lewis Pemberton*. Professor Hibbard has demonstrated that they (and other poems) synthesize a series of conventions to do with an ideal of country life which is intimately connected with the idea of a georgic rural retirement. The poets like their houses to be long-established, of the landscape. As Jonson put it:

And thought thy walls be of the countrey
 stone,
They are rear'd with no mans ruine, no mans
 grone,
There's none, that dwell about them, wish
 them downe;
But all come in, the farmer, and the clowne:

The lines are self-explanatory and point to the social aspect of these Prospects, for they represent the effect on the landscape of enlightened patronage, a patronage which is offered irrespective of who asks for it. And Jonson introduces too the idea of social concord, perhaps signified by those juxtapositions of working and playing figures in *Bifrons Park*. In the painting all accept the meaning of the house in the landscape as good and socially inevitable. Part of the house's goodness comes out in its self-sufficiency; the gardens and estate furnish all the requirements of the landlord and his dependants, and the poets tend to celebrate the practical aspect of this. Herrick describes how:

... laden spits, warp'd with large Ribbs of
 Beefe,
Not represent, but give reliefe.

The idea, based of course on fact, of the great hall being where high and low congregated and ate is celebrated in these poems, and hinted at in the careful descriptions of cultivation and kitchen gardens in the Prospects.

These paintings imply a pleasurably harmonious rural society, but there was a large gulf between those who formulated the myth and those who merely played out their parts. The proletariat and the ruling class may happily coexist in art or poetry but, it seems, not in life. Timothy Nourse mused upon this in *Campania Foelix* of 1700. Writing of 'our Common People', he was forced to the conclusion that it would be 'more easie to teach a Hog to play upon the Bagpipes, than to soften such *Brutes* by *Courtesie*', and class distinction might have motivated the critical rejection in the early 1700s of the attempts by Ambrose Philips to couch pastoral poetry in more realistic language. It was untenable. The upper classes liked to think of the pastoral as reflecting their own lives, which did not allow for slatternly milkmaids or sheep with the rot.

It is worth remembering that reality contradicted myth because it is neither evident from poetry nor from Prospect paintings. The actual style of these works is very much at one with their function as records of appearance. Paint is applied carefully and meant to describe what is there, and hence there is a strong element of documentation. And it is feasible to assume that if the artist told the truth about the house and grounds, then he must have done so too with the figures in the landscape. However, hawking parties or haymaking rustics are, rather, typical incidents, signifiers of the philosophy of country life in which the patrons of these pictures liked to believe. It is symptomatic of a social position which is absolutely confident in its control of both landscape and inhabitants that so many figures populate these paintings, for they are motifs with their own iconography. They point to the greater meaning of the landscape as a whole, reflect something of the same assurance which Marvell's *On Appleton House* (a later country house poem) reveals in the lines:

A Stately *Frontispiece of Poor*
Adorns without the open door

These poor are the introduction to the conventional account of the patron's virtue as shown in his way of life.

15
JAN SIBERECHTS (?):
Bifrons Park, Kent.
c. 1705-10. Oil on
canvas. New Haven,
Yale Center for
British Art, Paul
Mellon Collection

The Prospect depended of course on the patronage it celebrated, and artists would be unlikely not to flatter their patrons by casting their estates (and by implication them) in the best possible light. It was a persistent way of seeing: *Weald Hall* (*Plate 16*), painted in the 1720s, can be apprized in terms used for paintings of the 1680s, and we shall even find Constable purveying something of the same message by similar means as late as 1816 (*Plate 100*).

More immediately Prospects led to a type of agricultural landscape painting which is effectively the country house painting minus its country house. An early one is Siberechts's precise 1692 view of Henley on Thames (*Plate 17*), in which town and river play the role more normally assumed by the mansion. Carefully composed so that an oak creates a *repoussoir*, or wing of the foreground, past which we survey the green and sunlit valley landscape, Siberechts included enough incidental detail to guide our response to the painting. A cowherd and a maid appear down the track to the left as exemplars of the amiable rustics the area produces, and in the nearer meadow is a busy scene of haymaking. The town, plying its trade and industry by the river, is assumed, as would the mansion be in the Prospect, to have a favourable influence on what we see before us. There is not a mansion in sight, however.

This is an early example of what became a long-lived type of landscape painting. It indicates a shift in taste towards straight landscape which is confirmed by two other paintings, both thought to have been done around 1720, both featuring haymaking, and both probably by native artists. These are the extraordinary *Dixton Manor, Haymaking* (*Plate 18*), and the unimpressive *Hawking and Haymaking* (*Plate 19*). The former is a primitive work showing an extensive view over the Cotswolds, with the hayfield smack in

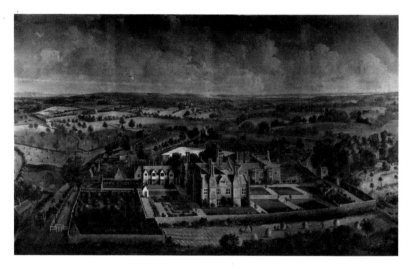

the centre. One of the fascinating things about it is the artist's concern to describe everything haymaking involved. We are shown grass being mown and tedded, in corners of the fields tiny figures repose, and at the bottom right a line of Morris men leave a field, their dance imitated by the lines of mowers or rakers. This painting, then, describes haymaking, and is besides a valuable record both of the way it took place and of the rituals involved. It puts one in mind of Thomson's opening to his description of haymaking in *Summer,* first published in 1727, and later incorporated as one book of the *The Seasons* (1735), of how the village 'swarms ... o'er the jovial mead'. Contemporary poets were themselves returning to the georgic at this time. One major tenet of *The Seasons* is that cultivation denotes civil advance, but the georgic came easily to poets who found Augustan Rome the only fair parallel for contemporary Britain. In 1713 Pope, having described the rural economy of Windsor Forest, concluded with the memorable couplet:

Rich Industry sits smiling on the plains,
And peace and plenty tell, a STUART reigns.

If the poet's peace and plenty are related to Baroque allegorical figures, their attributes in landscape painting are the scenes of cultivation and industry shown

16
Weald Hall, Essex.
c. 1720. Oil on canvas.
Attributed to William van der Hagen.
Brentwood School, Essex

17
JAN SIBERECHTS:
Landscape with Henley-on-Thames.
1692. Oil on canvas.
Collection of Lord Middleton

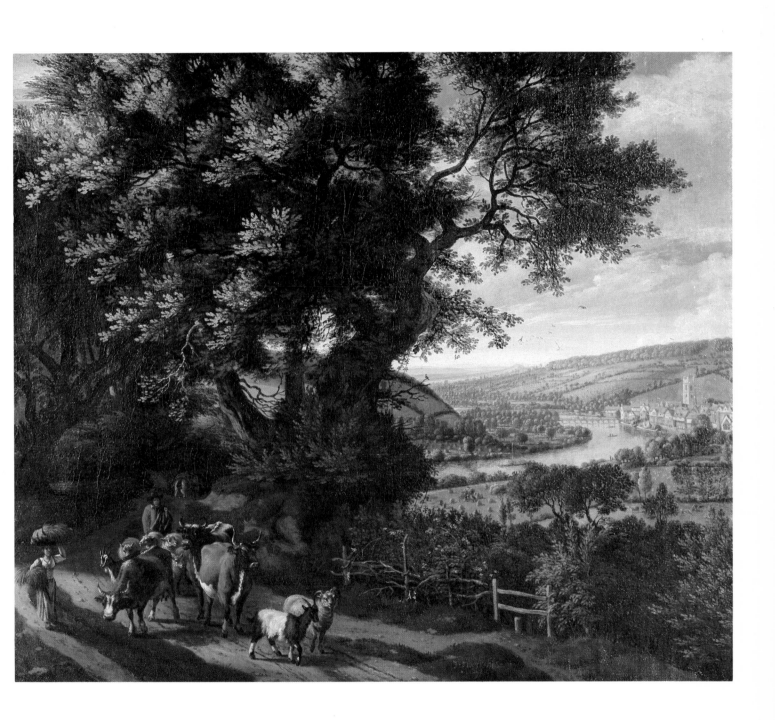

round Henley by Siberechts, or in hay-making landscapes.

Hawking and Haymaking is incompetently painted and awaiting an attribution. It illustrates episodes (which have a precise iconography) and places them within the context of the place shown. The picture is very busy, and to discern everything going on takes some time. Play and work coexist, which we should notice as approvingly as those mounted figures to whom the labourer is doffing his hat. There is a sense of light-heartedness, helped by the fact that not many people are actually labouring, and by an amorous scene of a type which became standard in later haymaking pieces. If one can be so imprecise as to write of poetry and painting being similar in 'feeling', here there is something close to the way Thomson continues that passage, which begins with the village swarming o'er the jovial mead:

While heard from dale to dale,
Waking the breeze, resounds the blended voice
Of happy labour, love, and social glee.

Haymaking meant that summer had come and with it relaxation and dalliance. In this painting it retains its time-honoured function as an indicator of the season while representing the happy society which inhabits what the poets had come to think of as 'Britannia'. The celebratory and sportive nature of the activity is reflected in the scenery itself, so rather than associate this civilized pleasure with a country house, we think of the qualities of the landscape.

Haymaking iconography was persistent. Hogarth concentrated rather on the 'love, and social glee' when he added a boisterous subject to a landscape by his friend George Lambert in the 1730s (*Plate 20*), and the same kinds of incident rather more tidily embellish Gainsborough's 1755 *Landscape with a Haycart* (*Plate 21*), which clarifies the same elements as in *Hawking and Hay-*

making, and is painted far more elegantly (the distance being particularly beautiful). Gainsborough still stresses the convention. While a couple of men load the wagon, their colleague is dallying, and the whole scene is presented as something for all to watch through the observing crones leaning on the gate.

These two paintings show something of the improvement British painting had made, and I shall interrupt the narrative briefly, to give some explanation for this. Thanks mainly to Hogarth, British painting was, by the 1730s, expanding both in quality and range, and artists were themselves grouping together in London. Hogarth reopened the St Martin's Lane Academy (where one could get instruction and draw from the model) in 1735 and it became the natural meeting-place for painters. They could begin to be surer of making a living because patronage was no longer a preserve of the upper classes. Middle-class entrepreneurs were beginning to take an interest in art. They provided a significant section of the market for Hogarth's prints, and the very existence of the St Martin's Lane School demanded an art-buying audience for its support. Hogarth made sure that the public for its part became aware of native art when he assumed responsibility for providing decorative pictures for Vauxhall Gardens in the 1730s, and by having British painters donate works to the Foundling Hospital (where they could be seen by visitors) in the 1740s.

Among the painters associated with Hogarth were George Lambert, the amiable Francis Hayman, and later Hubert Gravelot, the French engraver. These artists had significant literary connections and many of their preferred themes can be found in poetry or novels: for example Hayman's cheerful rural scenes, done after 1740 for Vauxhall Gardens, portray rustics with some resemblance to the amiable clowns in Gay's *Shepherd's Week* (1714). Hogarth

18
Dixton Manor, Haymaking. 1710-20. Oil on canvas. Artist unknown. Cheltenham Art Gallery and Museum Service

19
Hawking and Haymaking. c. 1720. Oil on canvas. Artist unknown. Upperville, Virginia, Paul Mellon Collection

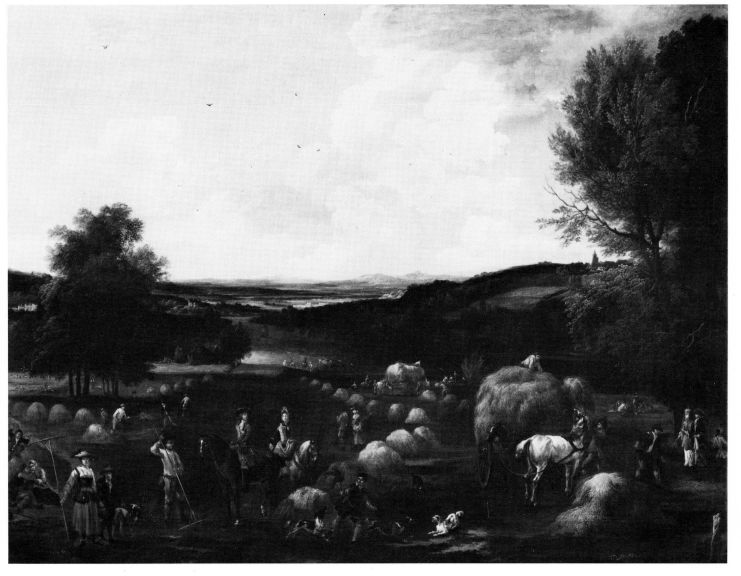

and his circle did not shy from the materialist side of modern culture, but, rather, celebrated it. In *Industry and Idleness* (1747) Hogarth's Industrious 'Prentice became rich and Lord Mayor of London because he worked hard, while the Idle one gets hanged after a life which has steadily degenerated precisely because of his distate for work. Richardson subtitled *Pamela* (1740) 'The Reward of Virtue'; a marriage above her station being Pamela's reward for having the acumen to hold out for the highest price for her virtue. Conversely Hogarth's Harlot progressed downhill in 1732 partly because she had squandered her virtue too soon.

These painters took naturally to the georgic, and Lambert has left one extremely interesting agricultural landscape. His *Hilly Landscape with a Cornfield* (*Plate 22*) has proved topographically baffling and is currently thought to show somewhere in South Bedfordshire. The painting is not without qualities. Lambert took over a dry and descriptive technique from the Prospect painters and used it to detail a scene of extreme breadth. Its main constituents are to the left an extensive cornfield, and to the right a grassy foreground embellished with a group of figures. A line of trees recedes into a distance, comprising wood and meadow, with chalky hills declining to the right. The sky is a fine piece of painting, and the picture deserves its reputation as one sign that by then British painting had begun to improve. The landscape is given enough detail to make it look as if it ought to be topographically specific, but without the pretext of a country house. The figures in the right foreground have the same function as those in the foregrounds of Prospects and provide the connoisseurs studying this picture with staffage with whom they can identify. In this instance one appears himself to be drawing the scene, and the way his standing companion draws our attention to this is a none too subtle way of suggesting that the painted landscape itself is one that deserves our approbation. Its only conspicuous feature, apart from the singular formation of the hills and the towns smoking in the distance (as they tended also to do in Thomson's poetic descriptions), is that cornfield. It is cut by a token reaper, and the way his companion attracts no notice as he chats with a wench suggests that the labour is not compulsory, a tribute to the society in which Lambert is painting because this group implies that the proletariat works of its own free will, knowing that this is to the common good. Cornfields traditionally signify high summer, and Lambert's use of one in this respect has not changed much from Bruegel's, but in Augustan England they had come to mean more. In *Autumn* (1730) Thomson found cornfields a 'gaily-checker'd heart-expanding view' and drew the moral that:

These are thy blessings, Industry! rough power!
Whom labour still attends, and sweat, and pain;
Yet the kind source of every gentle art,
And all the soft civility of life:
Raiser of human kind!

To Lambert and his contemporaries cornfields signified the successful conclusion of labour, the labour which was itself necessary to the preservation of civilization, and the success which was gauged through the wealth the corn would bring. Not only would no one starve, but corn could be traded and become an integral link in that complex of agriculture, manufactures, and arts which comprised the contemporary georgic ideal realized in terms of 'Happy Britannia'.

Gainsborough also painted georgic landscapes in his Suffolk period, which lasted from 1748 until 1759. He had moved into the St Martin's Lane circle on coming to London in 1740 and had learnt much from Hayman. His middle-

20
WILLIAM HOGARTH and GEORGE LAMBERT: *Landscape with Haymakers.* 1730s. Oil on canvas. New Haven, Yale Center for British Art, Paul Mellon Collection

21
THOMAS GAINSBOROUGH: *Landscape with a Haycart.* 1755. Oil on canvas. Woburn Abbey, Bedfordshire

class origins would have made him receptive to the ideology of his peers, as his painting proves. Good examples are the 1755 commissions from the Duke of Bedford, who may also have ordered Lambert's *Cornfield*. *The Woodcutter and the Milkmaid* (*Plate 23*), is as remarkable as his haymaking scene mentioned above (*Plate 21*). The painting is technically superb, and the composition has had its fair share of art-historical attention because of its sensitive response both to Dutch seventeenth-century models and French Rococo influences. From our point of view it should be pointed out that Gainsborough has painted a view down to Ipswich and has therefore located his subject; accordingly the ploughman is behind the local type of plough. But as John Barrell has pointed out in *The Dark Side of the Landscape*, he is also serving in the Thomsonian sense as a type of Industry, a georgic figure, and as we saw both industry and idleness in Lambert, here the foreground group contrasts with the working ploughman behind it, perhaps to continue Lambert's message about all realizing their stake in society. Alternatively, as Julian Gardner has suggested, it may make a more mundane social observation. The woodcutter and the milkmaid are on uncultivated common ground, and are therefore independent peasants not compelled to labour, unlike the ploughman, who is at work on enclosures owned by a farmer.

A painting like this shows the sophistication of agricultural landscape in the 1750s. As we shall see in the next chapter, landscape painting had by now become complex enough to make it impossible to follow particular tendencies at the expense of others. There is a hint of this for example in the fact that Gainsborough's scenes can be related to Dutch or French models for this means that landscapes from those countries were by this time known to artists and, one assumes, to their patrons, and that

accordingly a far wider interest in landscape had developed. As this had actually been happening since the 1720s we must retrace our chronology and single out the more important trends.

The Prospects and the agricultural landscapes to which they gave rise suggest some interest on the part of both patrons and artists in their surroundings. By the 1710s this had become for some a positive engagement with nature itself. This decade saw Pope in *Windsor Forest* describe its actual rural economy in emblematic terms, and write essays satirizing the prevalent formal style of gardening. In this reaction to artificiality he was not alone. Addison mused in 1712 that 'there is generally in Nature some thing more Grand and August than what we meet with in the Curiosities of Art', while Stephen Switzer published *Ichnographica Rustica* in 1718 to promote the French style of extensive Forest gardening against the contemporary 'Dutch' taste (shown in some Prospects) of ornamental parterres of lawn, or neat flower beds bounded by box hedges. Historians tend to concentrate on the exception at the cost of the rule, but slowly, particularly through the impetus of the group gathered around the Earl of Burlington, which included Pope and William Kent (*Plate 29*), a 'landscape' gardening style of lawn, grouped trees and water was evolved, which in its randomness was far closer to nature than anything the eye had previously seen.

Poetry too reflected this interest in landscape. Thomson's *Seasons* is the great example, but contemporarily John Dyer in *Grongar Hill* (1726) wrote that:

Grongar Hill invites my sojgng
Draw the landskip bright and strong;

and there is no doubt that cultivated society was beginning to take a greater interest in its surroundings, and to find them a source of pleasure. Painting shows the variety of approaches developed at some speed from this time on.

Various signs indicate that the taste for landscape was developing from the late 1720s. Lambert's copy after Claude's *Landscape with Mercury and Io* (*Plate 24*) of around 1740 reveals that connoisseurs had by then learnt to value the works of this great artist even if they still found a cheaper copy almost as good as the real thing. Lambert produced other pastiches of the Roman painters, and this was an activity in which John Wootton, normally employed in portraying the gentry and their horses, also indulged (*Plate 25*). Such paintings, particularly Wootton's, do not pretend to be of high quality and were probably meant merely to complement the furnishing of a particular room (*Plate 26*). Nevertheless they must have been produced in response to a demand and are another aspect of that same phenomenon of growth in the arts for which other evidence is the consolidation of artists under the guidance of Hogarth.

One of Hogarth's pet bugbears was the refusal of the British patron to pay for British art when he could have a value-guaranteed Old Master. Lambert's and Wootton's classical landscapes reflect this. They have few pretensions and were examples of a genre which the connoisseur, educated by Jonathan Richardson's writings, knew to be less worthy of esteem than history painting, or even portraiture. It is worth remembering that landscape was still at this time a relatively unimportant constituent of British painting. 'Face painting' was the sure way the native artist could then make a living, and it is one of portraiture's branches which we shall now consider to find evidence of a more general taste in landscape. This is the kind of small group portrait usually called a 'conversation piece'. It appealed to the British because it was cheap, being small and showing numbers of people on the one canvas rather than each on a separate one.

It is usually thought that the genre

developed in direct response to the *fêtes champêtres* evolved pre-eminently by Watteau in France, and immediately transmitted to Britain by the French painter Philippe Mercier (of course, the detailed story is rather more complicated than this). Although a relatively late example (Hogarth had been turning out comparable work since the late 1720s), Mercier's conversation of *Frederick Prince of Wales and his Sisters* has its sitters showing off their musical talents against the backdrop of the Dutch house at Kew (*Plate 28*). It is typical of the genre, with its close attention to physiognomy and its display of the refinement of its subjects, who not only appreciate the country life at Kew, but also find it a suitable setting for music-making.

That the conversation had other possibilities was demonstrated by Hogarth in two small subjects in landscape settings, *Before* (*Plate 27*) and *After. After,* the

24
GEORGE LAMBERT:
*Classical Landscape,
after Claude's
Landscape with
Mercury and Io.
c.* 1740. Oil on canvas.
Buscot Park,
Gloucestershire

25
JOHN WOOTTON:
*Classical Landscape.
c.* 1740. Oil on canvas.
Manchester,
Whitworth Art
Gallery

26
JOHN WOOTTON:
Landscape. c. 1740s.
Oil on canvas. London
School of Economics

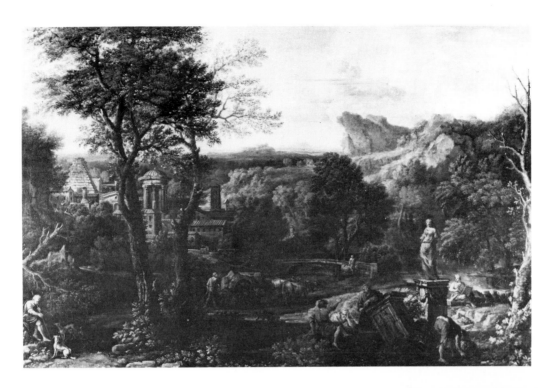

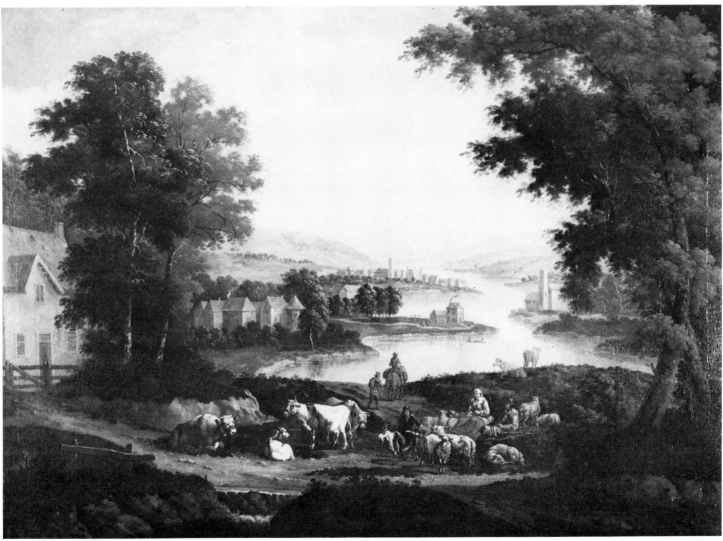

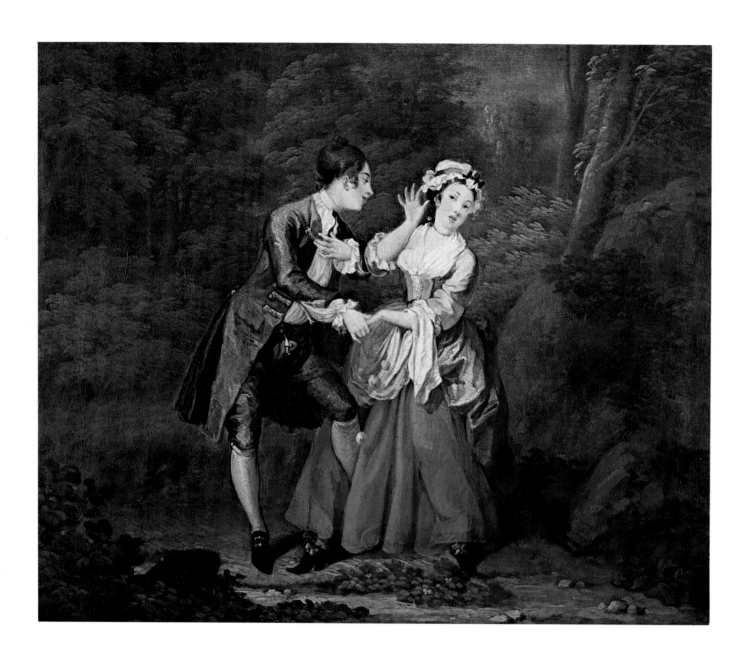

pair to the painting reproduced here, shows the couple exhausted at the close of the discussions into which they are entering.

The conversation piece as painted by Mercier was extremely popular, and there are some fascinating examples of the late 1730s and early 1740s which, thanks to the researches of Dr Harris, we can now see to be within the 'sub-genre' of conversations in gardens started with

Rysbrack's 1729-30 views in the grounds of Chiswick House.

In 1738 Balthasar Nebot produced eight paintings of scenes in the grounds of Hartwell House (*Plates 30 and 31*). The staffage of these pictures is both genteel and humble, and we learn from them not only how the grass was kept down but also how such gardens were used. They confirm the suspicion that by this time landscape, at least if under

27
WILLIAM HOGARTH:
Before. 1730-1. Oil on canvas. Cambridge, Fitzwilliam Museum

28
PHILIPPE MERCIER:
Frederick Prince of Wales and his Sisters. 1733. Oil on canvas. London, National Portrait Gallery

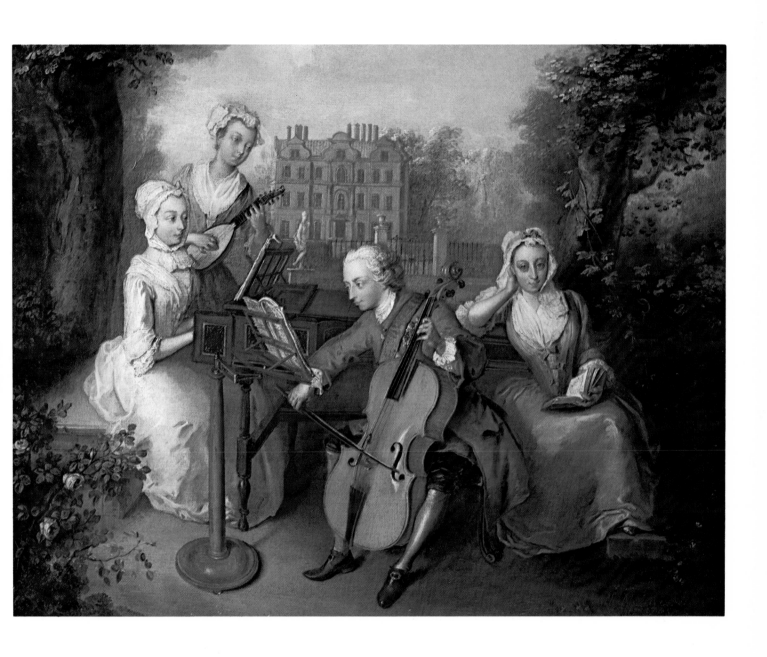

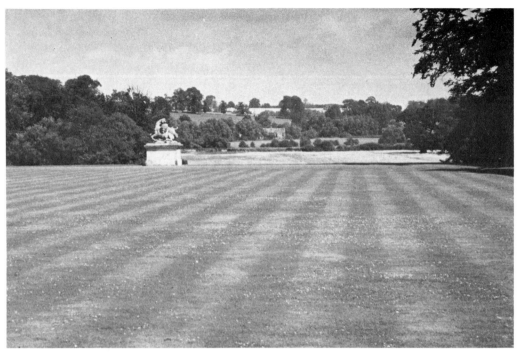

some control, was becoming a place of leisure and recreation. The Hartwell gardens need only be contrasted with those of Hampton Court (*Plate 14*) to show how far towards informality taste had moved. The landscape beyond the grounds is now permitted to form part of a more general composition although a line of demarcation between it and the gardens remains. Paintings like Nebot's often have great appeal: this is equally so with Edward Haytley's painting of 1774 of the Montagu family at Sandleford Priory (*Plate 33*). Like Lambert's *Cornfield* it shows us a scene in which the figures direct us to admire what they also see. Having become tired of bowls, the Montagus are positioned so that they can either prospect the view through a telescope, or just look out across the terraces with their haymakers (one of whom sleeps) towards the village itself. Haytley defines precisely that idea of haymaking as a *motif*, to be enjoyed on its own terms, which we have discussed in relation to the more conventional agricultural landscapes, and he shows too how fast the idea of 'calling in the country', associated

usually with the gardening of Bridgeman and Kent (*Plate 29*), had caught on.

At Rousham the bowling-green terrace was designed by the latter to incorporate the cultivated scenes beyond the Cherwell as part of the landscape: it made it seem as though all was contiguous, although the garden and fields were actually separate. Thus while the Montagus take pleasure in the haymaking and village scenes and see them as part of their garden landscape, in reality there is a divide, an area of separation. This may indicate a necessity to keep reality at a distance if it was to accept a georgic interpretation, as Gainsborough suggests in his *Woodcutter and Milkmaid*. Nevertheless the Montagus enjoy these rural scenes, and from pictures such as these we can ourselves study those who created the market for georgic landscape paintings.

Rarely does scenery play as specific a role as this in conversation pieces, and we can contrast the rule, as represented by Devis (*Plate 32*), with the exception, provided by Gainsborough (*Plate 34*), both painted in the period around 1750.

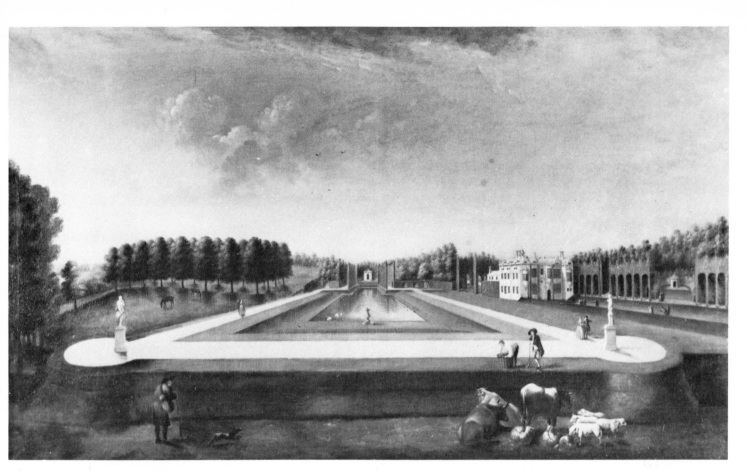

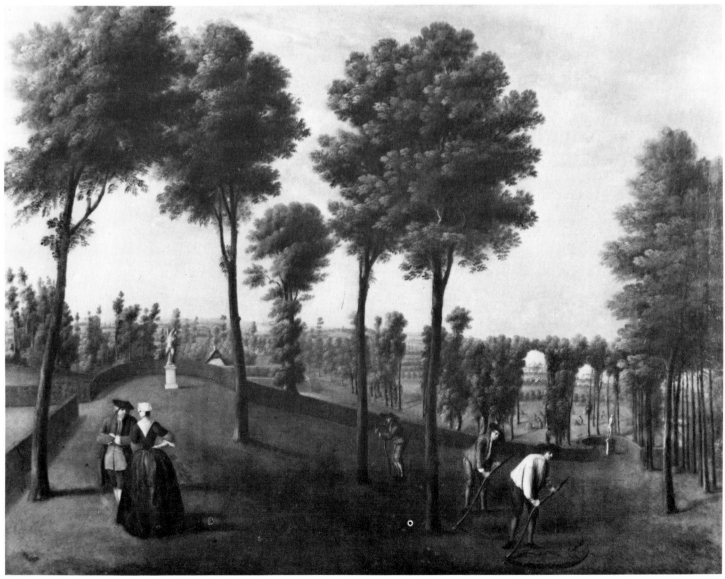

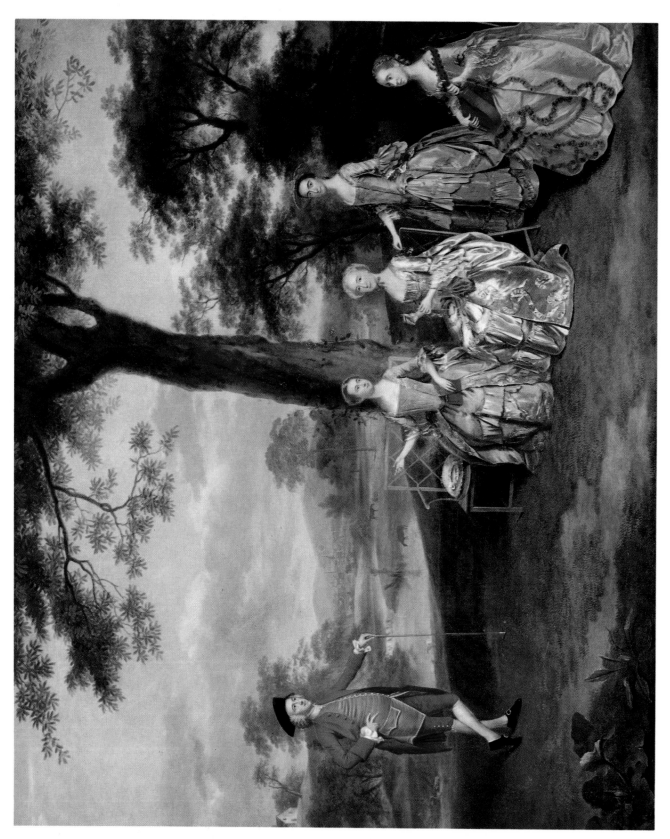

32 ARTHUR DEVIS: *Edward Rookes-Leeds and Family*. *c.* 1760. Oil on canvas. Private Collection

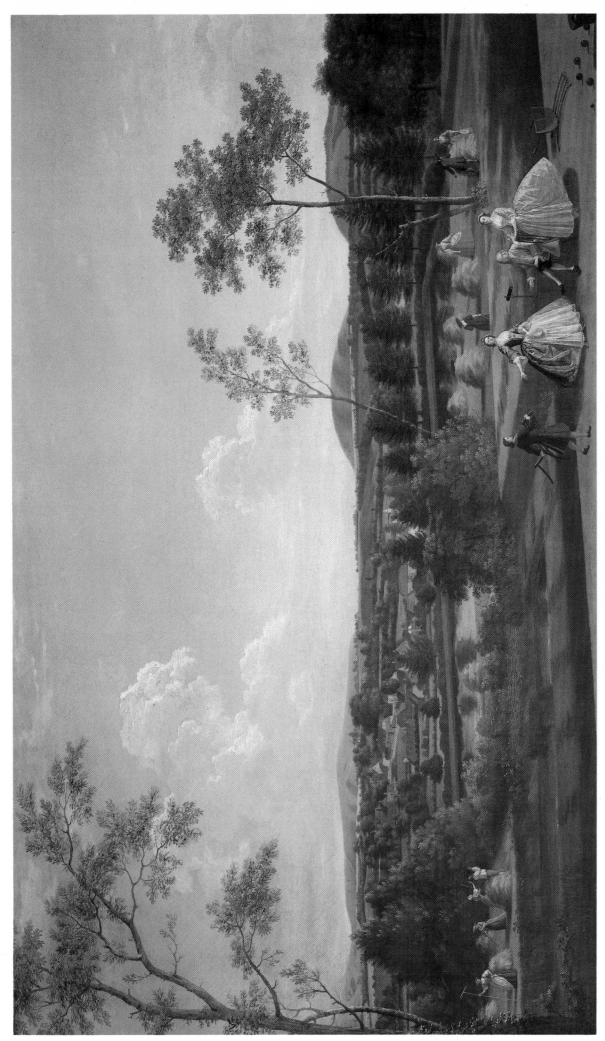

33 EDWARD HAYTLEY: *Sandleford Priory*. 1744. Oil on canvas. London, The Leger Galleries Ltd

Devis uses landscape not for its intrinsic value, but as a backdrop, and so shows that it had become fashionable, at least amongst the people who employed him, to betake themselves into country or parkland and appreciate it. The taste for scenery was now permeating downwards. This was not the case when Gainsborough used the format for a wedding portrait of Robert Andrews, whom he must have known personally, and his young wife Frances. Whereas his sources (Hayman's conversations of the Tyers family in particular) usually set their subjects in a park, Andrews's park is his farm, and we are meant to admire his progressive farming, lines of stubble showing that he has used a seed-drill, as well as his possessions: his dog, and his wife. Gainsborough set them in a lovely rendering of the view across the Stour Valley to Sudbury from the farm at Bulmer. The landscape is there for a purpose, as an attribute of its creator, and to have painted it so memorably Gainsborough must surely have been in some sympathy with his patrons.

Gainsborough is of course a major landscape painter, and his output at this period is yet another indication of the growing stature and confidence of the British School. His paintings show too a marked refinement in the general taste for landscape. Take, for example, one of the most famous of them, that remarkable and harmonious vision of the Suffolk countryside, *Cornard Wood* (*Plate 35*). Its adaptation of the forest scenes of Ruisdael is a further sign that a taste for Dutch landscape had developed, but I do not mean to analyse the image in terms of its sources. Rather I wish to remark on Gainsborough's consummate skill, and his fine management of blues, greys, greens and browns in an ordered composition describing terrain not implausibly like that around Cornard (which appears in the distance), and where the people go about their business without an aristocrat in sight. Gainsborough describes not only the landscape, but also the life it supports. Yet the relaxedness of such works was to vanish when, in 1759, he moved to Bath.

Gainsborough's art is evidence of the advance in British art in general since the 1710s. There was growing middle-class patronage, and artists were developing more corporate clout. From the 1750s moves were made to found an official Academy of the Arts, and this had a marked effect on the history of painting in general at this period. We have seen landscape grow in complexity, and from the 1750s matters become so complicated as to demand another chapter.

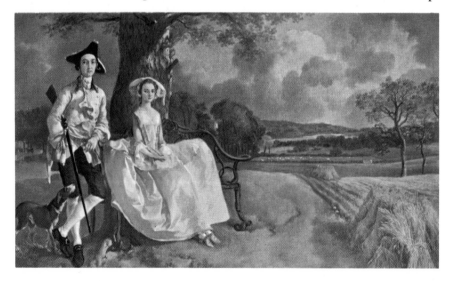

34
THOMAS
GAINSBOROUGH: *Mr and Mrs Andrews*. *c*. 1748-9. Oil on canvas. London, National Gallery

35
THOMAS
GAINSBOROUGH: *Cornard Wood*. 1748. Oil on canvas. London, National Gallery

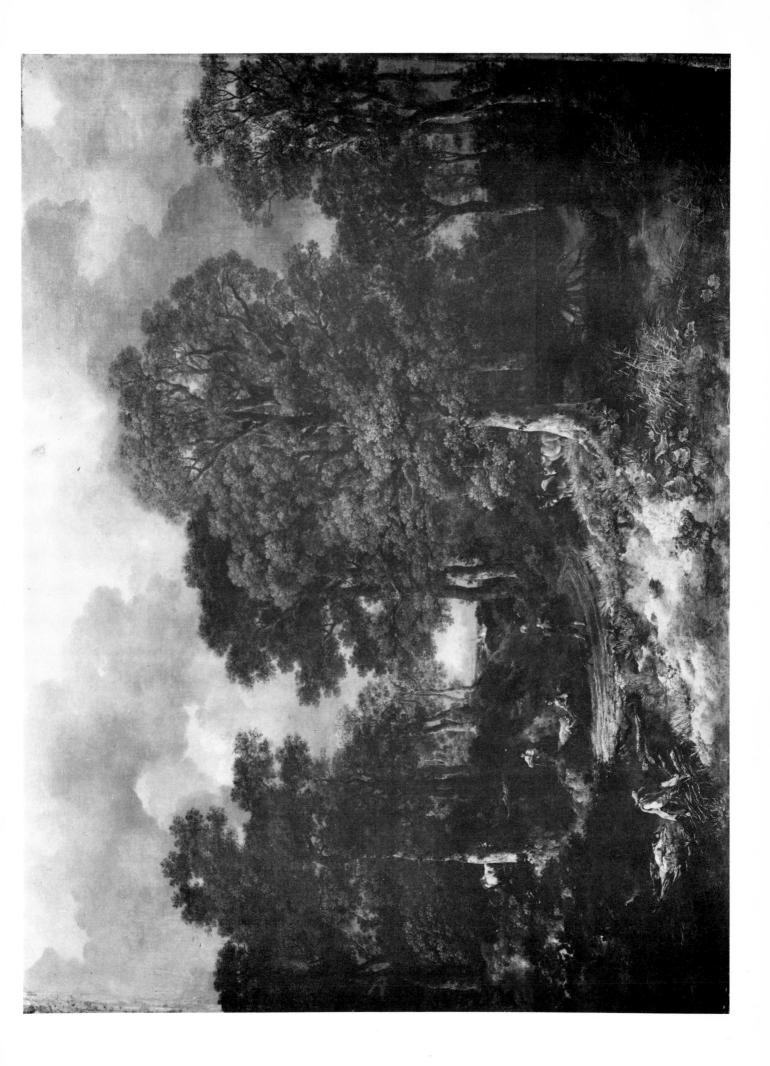

3 The Expanding Horizon

After the later 1750s landscape painting branched out into several distinct types, although there was a temporary disappearance of the agricultural genre, which had been so prominent up till then. We can isolate two main trends; some artists preferring to depict ruins (*Plates 38 and 41*) and others wild scenery (*Plates 45 and 50*). The same period sees the appearance of distinguished landscape painters like Gainsborough (*Plates 58, 59, 61-3*), Wilson (*Plates 37, 48, 52, 54 and 55*) and Wright of Derby (*Plates 56, 57 and 60*). While all produced work which historically can be seen as illustrating, say, the taste for sublime scenery (*Plates 52 and 63*) they demand individual notice simply because their work is so good. These disparate strands do not make for a coherent narrative, and I shall have to go backwards and forwards through the decades.

In the late 1750s there was a curious concatenation of circumstances in British art. The British School was beginning to consolidate, and by this time could boast some excellent practitioners: Hogarth, Ramsay, Reynolds, Sandby, Gainsborough, and Wilson, to name but a few. The artists were, furthermore, becoming more organized, the clearest indication of this being the start of public exhibitions from 1760 at the Society of Artists. Indeed attempts had been made to found an Academy as early as 1753 and these came to fruition in 1768 when under royal patronage the Royal Academy began life. Reynolds, its first President, was whole-heartedly dedicated to furthering the high claims of British art and giving the nation a school of artists of which it could be proud. The Academy standardized the education of art students and established too a hierarchy of recognition, which must have created a sense of painting being a profession that brought its own rewards. But the Academy's relations with certain artists, particularly Gainsborough and Stubbs, showed its monopoly to be far from total.

The British School was now more secure than it had been probably since the Middle Ages, and the public exhibitions meant that artists were beginning to have a more confident relationship with their buying public, now offering their works for direct sale from exhibition rather than relying on a patron's favours. Thus painting came to reflect fashions in that certain types of picture could at various times be fairly certain of a sale, and in theory at least artists had to key themselves in to public taste. Instead of producing what the patron dictated, the artist came to have a rather more flexible relationship with his or her audience, and the state of affairs where a canvas was bought direct from exhibition precisely because its painter was currently fashionable was quickly reached. The best-known instance of fashion affecting sales was Reynold's foisting portraits of ladies disguised lumpishly as classical deities onto a public which in *The Discourses* he had advised should admire history painting.

The continuing boom in face painting goes some way towards pointing to the decisive factor in the strengthening of British painting, the increasing number of people with money. Some had always had it, but now we find those who have made a fortune seeking social consolidation: contemporaries would have instantly recognized this as one theme of Hogarth's series *Marriage à la Mode* (1745). There are many other pointers to a new market forming itself, much of the new wealth being created either through the expansion of trade and industry or through the exploitation of distant colonies. This increase in wealth meant that the rival architects Adam and Chambers could operate independent practices, advertising their respective merits through strategic publication of their designs, and then awaiting custom. Likewise in gardening Lancelot Brown advertised his services and took on floods of commissions. Dorothy Stroud estimates some 211 proposals for landscaped grounds which, contrasted with the practice of Kent, confirms that gardening was popularly fashionable. Brown's designs at Nuneham Courtenay in 1761 for the 1st Earl Harcourt involved the demolition of a village to open up the views from the new house, and provoked Goldsmith in *The Deserted Village* to mourn this as an act of social vandalism:

… trade's unfeeling train
Usurp the land and dispossess the swain;

Note the terminology, with 'trade's unfeeling train' 'usurping' the land, which contrasts implicitly with the responsible estate management of established families, or so Goldsmith liked to think. Harcourt would have replied that in landscaping the grounds at Nuneham he was displaying the taste expected of him, and anyway he had rehoused the villagers in neat cottages a couple of miles away. In this attempt to acquire a taste we have one reason why the growing numbers of rich people saw fit to buy art. The georgic equation as stated by Thomson in *The Seasons* had efficient agriculture fuelling trade, which together with developing industry created a population with enough leisure to evolve its own culture; and as the remaining signs of the much admired Roman civilisation were its ruins, so the contemporary arts reflected the stature of the British, who in terms of military power and economic strength saw themselves as the Romans reborn.

In the late 1750s then there is an expanding group of people with an interest in the arts, people with both money and leisure, and accordingly with cultural aspirations. This group comprised not only the aristocracy, but also a growing metropolitan, provincial, and rural bourgeoisie. We can call it a new 'spectating' class; its members were virtually compulsive travellers and from this period onwards took a real interest in what there was to be seen. Its symbol is perhaps the town of Bath, which developed rapidly from the middle of the century as probably the only holiday resort ever to be designed in good taste. Its residents are identified individually in the portraits Gainsborough did after settling there in 1759. We might, from noticing the flourishing condition of painting, have drawn the conclusion that more people than previously were interested in it anyway, and this new enthusiasm is also one reason why aesthetic theorizing became a growth industry from this time onwards. If you know that you ought to be visually aware but are not quite sure of what good taste in the arts entails, then you will need guidance, and in the 1750s this came in the form of various aesthetic treatises.

Hogarth published his *Analysis of Beauty* in 1753, but more importantly, three years later, Edmund Burke gave the world *A Philosophical Enquiry into the Origin of our Ideas of the Sublime and Beautiful*. He stated in the Preface that

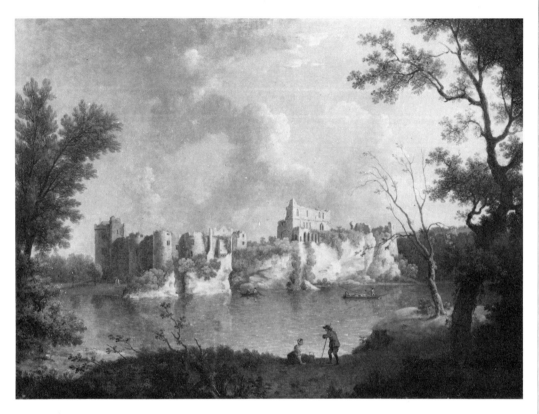

36
JOHN INIGO RICHARDS:
Chepstow Castle.
*c.*1757. Oil on canvas.
Cardiff, National
Museum of Wales

he meant it as a guide to reading the 'characters of nature'. Its reaching a fifth edition by 1767 is a measure of its popularity, for it must be supposed that such a book would have been passed around and thus have increased significantly its readership. Burke aimed to teach people to recognize what he saw as the chief characteristics of nature and so acquire a correct taste. Likewise, in his *Letters concerning Taste* (1755), John Cooper explained that 'a ... Depravity of Taste for the Arts and Sciences and natural Beauty, has ever attended a national Corruption of Morals', and dared his readers to expose themselves as boors by disagreeing with him. The same urge to educate public taste lay partly behind Reynolds's writing and publication of his fifteen *Discourses* from 1768 onwards. The production of these books presupposes a need for them, and this is another side to the great boom in painting which dates from this time. In landscape paint-

ing of this period various distinct developments formulated landscape-types of perennial popularity.

The British had always been interested in their medieval remains. Dugdale had written his *Antiquities of Warwickshire* in 1656, not long after Kierinx had done his landscape of Richmond Castle. In the 1700s Vanbrugh ignored Sarah Churchill's orders to demolish Woodstock Manor because he found it a valuable reminder of native antiquity. By 1750 this antiquarian interest was gathering some impetus, largely through the efforts of the circle gathered round Horace Walpole, who at Strawberry Hill created a house in a kind of Rococo Gothick, and in *The Castle of Otranto* wrote just the novel for its library. The taste for the medieval was scholarly; J. Bentham's *History of Ely Cathedral*, for which the plates had been done in 1755, was published in 1771, and Percy's *Reliques of Ancient English Poetry*, an

37
RICHARD WILSON:
Pembroke Town and Castle. c. 1773. Oil on canvas. Cardiff, National Museum of Wales

38
ANTONIO CANALETTO:
Alnwick Castle, Northumberland. 1749-50. Oil on canvas. Albury Park, Duke of Northumberland

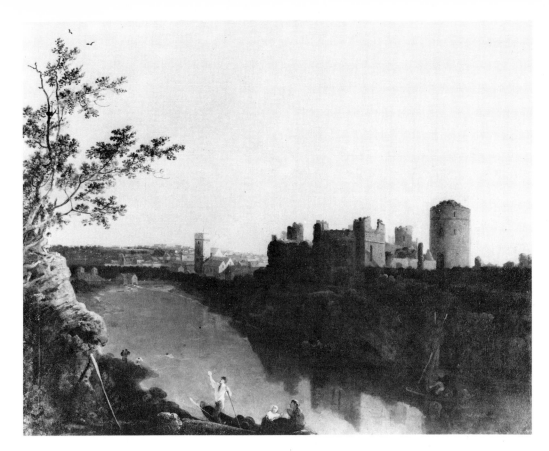

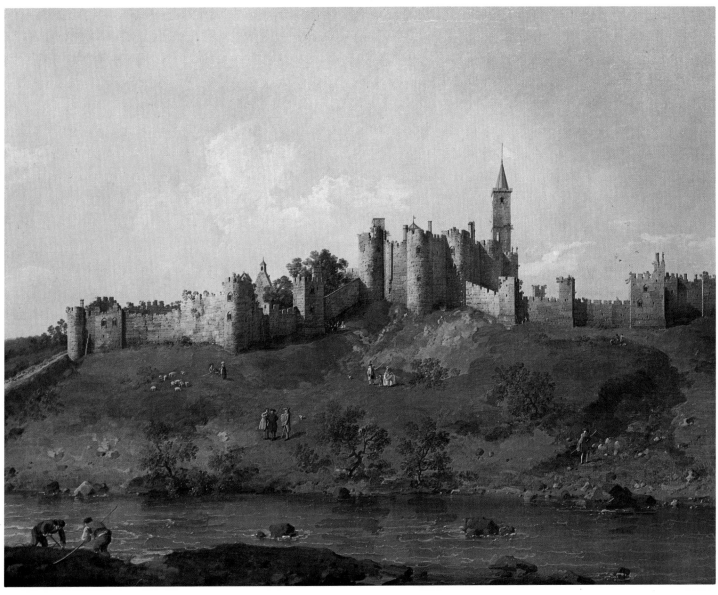

assiduous compilation of late medieval verse, was published in 1765 with a second edition two years later, and was the literary side to the same coin.

Reaction to medieval remains involved stock literary responses, defined early on and then repeated, which go under the general heading of 'graveyard melancholy'. The ideal place for its adherents to be was amongst tombs and ruins on a night when clouds scudded past the moon and the only identifiable sound was the howling of owls. Thus Mallett, in *The Excursion* of 1726:

Behind me rises huge an awful *Pile*
Sole on this blasted Heath, a place of *Tombs*
Waste, desolate, where *Ruin* dreary dwells
Brooding o'er sightless Sculls and crumbling
 Bones.

Such ghastly thrills were but one of the attractions of the medieval ruins in which Britain abounded. They acted too as reminders of a national past which it now became worthwhile to think of studying (*Plates 36, 40, 41*). This may well connect with that surge of patriotism around the time of the accession of George III. I have already mentioned how Britain was thought of as a modern Rome. And as the achievements of Rome were visible in her ruins, so it became possible to contemplate the glories of the British past evoked by the sight of indigenous remains. This sentiment is reflected in landscape painting.

Although the taste was not really defined until the 1770s, Canaletto had anticipated the ruin-piece in his *Alnwick Castle* (*Plate 38*) of 1749-50, where the castle, painted so as to emphasize its overgrown ruinous parts, is picturesquely ranged along the top of a slope on which enough figures are placed to show that such a site was becoming the fashionable thing to visit. I call this an anticipation because the medievalizing trend seems established in literature and architecture before painting. However, views across to evocative ruins were pro-

duced both by Richard Wilson (*Plate 37*) and John Inigo Richards (*Plate 36*). The latter may have borrowed his composition for *Chepstow Castle* from Wilson, but he treated his subject in a different way. The composition of a foreground with framing trees letting out to a middle ground of water and an enclosing distance is adapted from Claude, and Richards used it to structure a painting which in certain respects is clumsy, but in others not without refinement. The use of colour is sophisticated. This is particularly so in the way that the yellowed castle walls fade almost imperceptibly into the cliffs on which they rest, so that both through colour and a subtly ambivalent treatment of wall and rock Richards creates a sense of the ruins being organic to their surrounds. The declining sun's highlighting of the castle introduces a dramatic element enhanced by the cloud formations, and through such devices he conveys something of the enthusiasm the sight of such ruins could arouse.

Wilson was more abstracted in his portrayal of *Pembroke Town and Castle*, where he threw a similar composition out of kilter and drenched everything in an extraordinary golden-pink light. His chiaroscuro and the contrast of silhouette with reflection are what mark this as a superior work to Richards's. The latter used simple pictorial signs and his imagery is self-explanatory; Wilson took a similar motif but used it for personal artistic experimentation.

However, both were working in the same idiom, and another example is Paul Sandby's *Roslin Castle* (*Plate 40*). Done in mixed watercolour media around 1770, it portrays a ruin variously described as 'beautifully wild and awfully sublime' but also as 'much frequented in the summer by parties', the artist having captured both aspects here. The castle is mostly in shade, and rises greyly dominating from a dark green base, the sombre colours being continued into the

39
PAUL SANDBY: *Conway Castle*. 1777. Watercolour and bodycolour. Liverpool, Walker Art Gallery

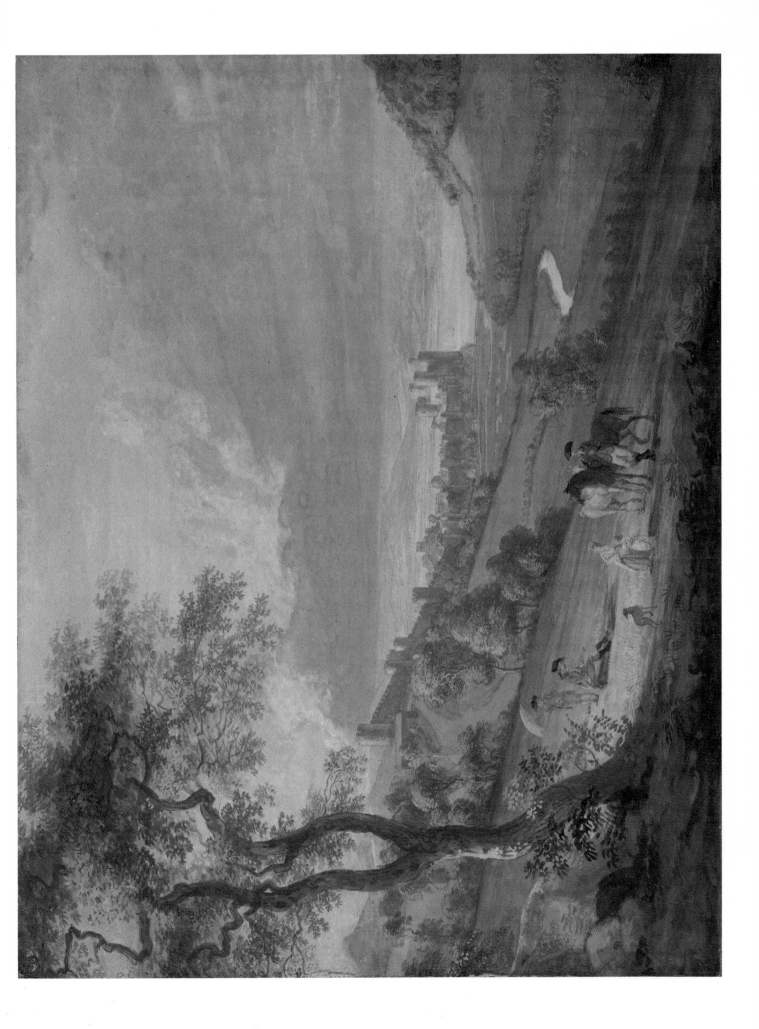

foreground, presumably to stress that mood of sublimity typically evoked by the locale. Nevertheless, in a pleasant patch of sunlight is a group of ladies, one of whom is herself drawing the landscape with the aid of a *camera obscura*, a box designed so that the image was refected onto a sheet of glass, on which thin paper was then placed and the outline traced. It was a fairly foolproof way of taking the likeness of a landscape, and its appearance here points to various things. Sandby meant his work to be cheap and attractive to buyers: watercolour paintings, being both, became increasingly popular (*Plate 39*). However, the medium was also portable (although in this instance there is no evidence of Sandby being anywhere near Scotland when he made the painting) and so convenient for quick work on the motif. And that group of ladies speaks eloquently about the demand for such drawings, shows that to be able to do them oneself was becoming a desirable attribute of anyone with polite pretensions, and tells us, in the same way as Lambert's earlier draughtsman, that if we ourselves are to demonstrate our good taste, we ought to admire the scene.

Such works aimed to satisfy a demand for images of popular sites and were produced partly with an eye to their souvenir value: as today we buy a postcard or stick of rock, in the eighteenth century the tourist liked reminders of visits he had made. Rooker's *Interior of Ruins, Buildwas Abbey* (*Plate 41*), a watercolour of around 1785, takes us inside a ruin rather than surveying it from a distance and contrasts past grandeur with present desolation. This is done by opposing figures and architecture to suggest the huge size of the rough-hewn Romanesque piers. The length of nave and choir is exaggerated by employing a trick played, too, by Piranesi to make the ruins of Rome grander in art than actuality: making the distant figures artificially small so as to falsify the perspective. There is an intentional poignancy in the incongruity

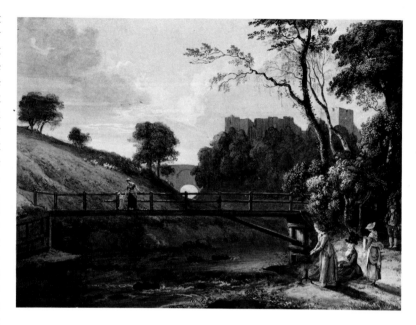

of this wrecked grandeur with the uses to which the Abbey is now put, as a shelter for hay, a wagon, and what are either rustics or gypsies. We feel the distance between the present and the age which constructed such buildings, and Rooker, producing a conventional image of British antiquity, connects it with the familiar idea of the artist being moved by the ruins of Classical antiquity. We play the role of the artist. Watercolour, which in the hands of topographers like Malton was generally used to fill in previously drawn outlines, here creates subtle effects of light and shade, and although this is one of many pictures of this kind, it is a distinguished example. Another was produced by Dayes in 1792 (*Plate 42*) in a large-scale distant view of Ely. He has a similar repertoire of figures, but these are more like Cambridgeshire rustics than Rooker's indeterminate ones, ambling around in front of the massive pile, depicted with an eye both for the play of light and shade along the surfaces of its stones and for the accurate delineation of fine architecture. And although for the moment I propose to leave the remains of the Middle Ages, we shall see

40
PAUL SANDBY: *Roslin Castle, Midlothian.* *c.* 1770. Pen and brown ink with watercolour and bodycolour over pencil. New Haven, Yale Center for British Art, Paul Mellon Collection

41
MICHAEL ANGELO ROOKER: *Interior of Ruins, Buildwas Abbey, Shropshire.* *c.* 1785. Watercolour. Oxford, Ashmolean Museum

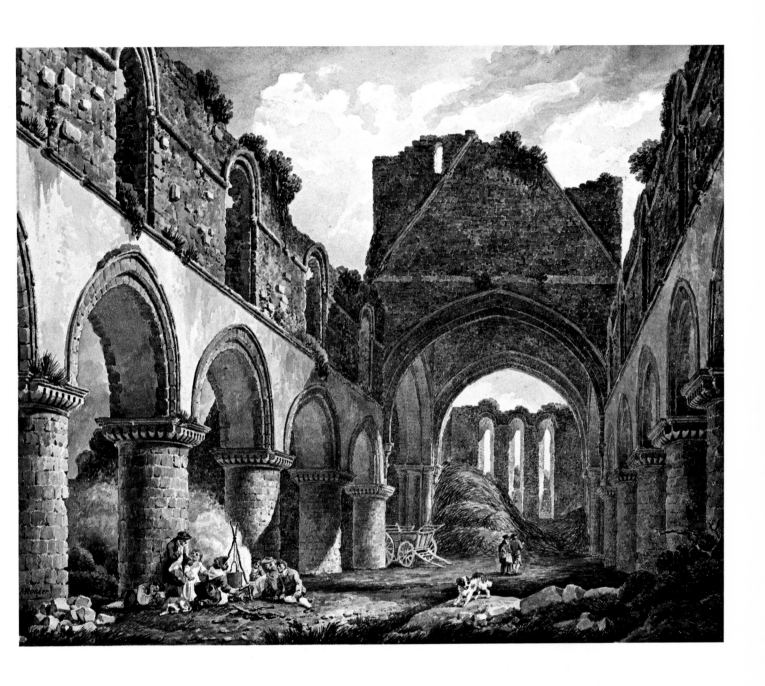

that they stayed attractive, for different reasons, to the subsequent generation.

To make cheap pictures of buildings and ruins, artists had to travel. To be sure of selling them they had to make sure that prospective buyers were doing the same kinds of travelling and were interested in the same sorts of things. To get from one ruin to another involved traversing terrain which could vary from the amenable to the horribly rough (*Plate 44*), and Ibbetson's picture has on its back a label stating that it represents an incident which occurred in Wales in 1792 while he was on a tour with John 'Warwick' Smith and the Hon. Robert Fulke Greville. Although to consider this painting disrupts our chronology, like Sandby's *Roslin Castle* the canvas reveals much about the activity we are about to describe. The terrain is wild and depopulated, the weather inhospitable. Fifty years earlier if someone had been caught in the circumstances here de-scribed, they would have given thanks for their escape, but hardly have com-memorated the incident with an oil painting. Ibbetson's picture tells that these travellers survived their adventure; making a pictorial boast which to be understood had to be seen by others who themselves had been involved in similar escapades in like inhospitable terrain. More than this, it is also just another picture of mountains, an example of a species of landscape which had by 1792 become commonplace. It seems that tra-vellers began to appreciate and notice the landscapes through which they passed — Skelton's view of Harbledown (*Plate 43*) glimpses it as part of land-scape. This village was in agreeable countryside, but often the terrain was as wild as Ibbetson describes. The more often passage through such landscapes was achieved without mishap, the less threatening they would seem. They might become inconvenient, but that

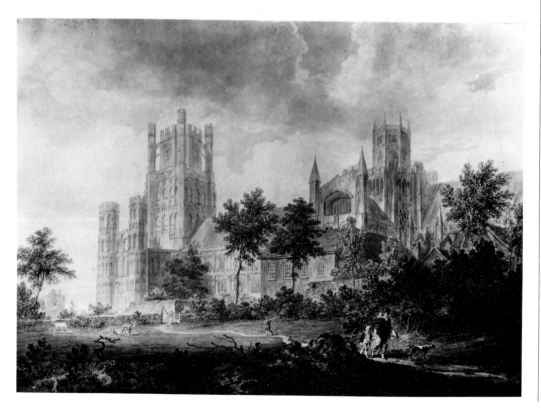

42
EDWARD DAYES: *Ely Cathedral from the South-East*. 1792. Watercolour over pencil. London, Victoria and Albert Museum

43
J. SKELTON: *Harbledown, a Village near Canterbury, Drawn Immediately after a Heavy Summer-Shower*. 1757. Watercolour over pen and black ink. New Haven, Yale Center for British Art, Paul Mellon Collection

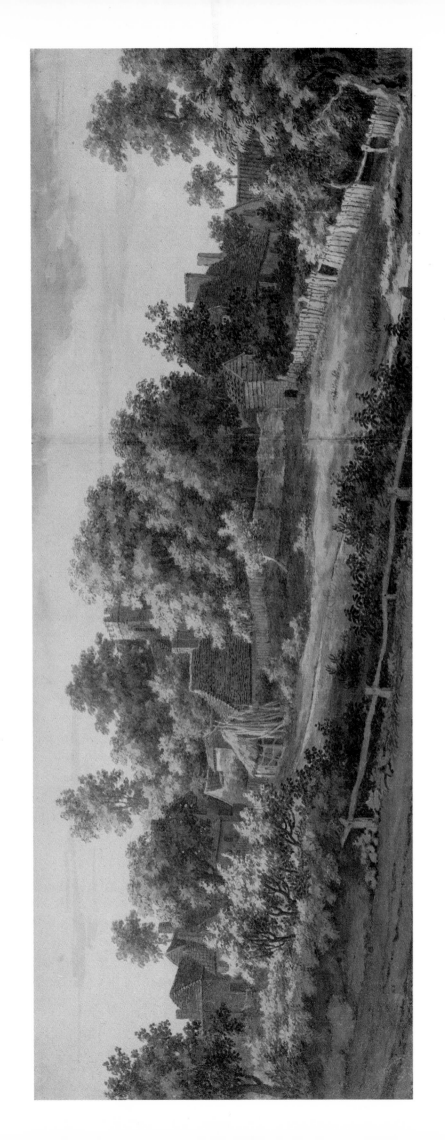

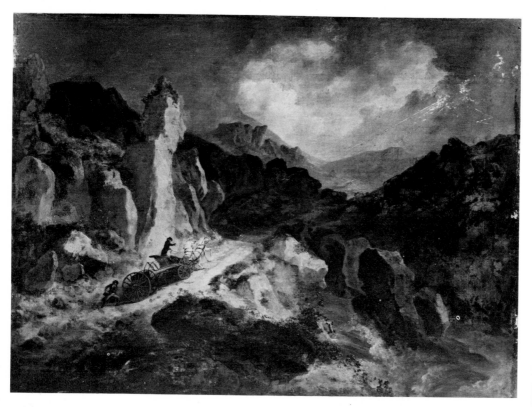

44
JULIUS CAESAR
IBBETSON: *Phaeton in a
Thunderstorm.* 1798.
Oil on canvas. Leeds,
City Art Gallery and
Temple Newsam
House

was matter for grumbling rather than terror.

We shall see that, parallel to the increasing interest in medieval antiquity, from the 1750s writers began to deal with areas like the Lake District or the Welsh Mountains, which had previously been considered too frightening to be perceived aesthetically. The taste was perhaps prefigured in Burke: his sublimity was most easily found in wild and mountainous regions, and his explanation of their effects would have gone some way towards disarming them of their terrors. I should like to look at one or two paintings as an introduction to a more specific discussion of the interconnection between writings on and paintings of particular locales.

While paintings of the wilder kinds of scenery abound in the later part of the eighteenth century, few were produced in its first half. An interesting example is Nebot's *Aysgarth Falls* (*Plate 45*), which almost certainly dates from before 1750.

Nebot featured earlier as the painter of the neat and ordered landscapes of the grounds of Hartwell House, and his excursion into sublime scenery makes something of a contrast with those works. At Hartwell he found no difficulty in composing his scenes, and they all hold together pictorially. He coped rather less successfully with a terrain of hills, rocks and rapids, having problems with making the water appear to flow on the horizontal rather than upwards, and clearly missing the guide lines provided at Hartwell by hedges and the edges of terraces and canals. The landscapes of course are incompatible. The garden scenes were humanized and in this sense comprehensible, whereas the only sign that Aysgarth Falls have been visited before are walls and paths. Otherwise the landscape is little touched by the improving hand of man, and of the type generally called a 'desert' and qualified with adjectives like 'trackless' in the eighteenth century, precisely because it

45
BALTHASAR NEBOT:
Aysgarth Falls. 1740s(?).
Oil on canvas. New
Haven, Yale Center
for British Art, Paul
Mellon Collection

lacked any intellectually imposed pattern of the kind that lines of enclosures might give it. It is probably fair to say that the artist had such obvious difficulties in realizing it as a painting because he had no pictorial armoury with which to attack it. Had he gone to the paintings of Salvator Rosa, he would have been able to conceive the scene through the eyes of art, and this would have divested it of some of its difficulties.

Indeed, the precedent created by Salvator, and to a lesser degree by Gaspard Poussin's wild landscapes, is relevant to this discussion. Thomson's best-known couplet from *The Castle of Indolence* (1748) is:

Whate'er *Lorrain* light-touched with softening Hue,
Or savage *Rosa* dashed, or learned *Poussin* drew.

It shows that the paintings of the masters were being used to characterize various kinds of landscape, the wild and sublime one being typified by the works of Salvator. And such artistic precedent (knowledge of it on the part of such as Thomson was part of the growing taste for landscape in general) would also help make such inhospitable scenes look less frightening. Although Nebot could not cope with the pictorial problems presented by hills and rapids, the painting reflects a developing taste for wilder landscapes, which was being displayed by connoisseurs by the 1750s.

In *High Tor, Matlock* (*Plate 46*), 1756, Alexander Cozens met far fewer problems in the pictorial conception of the scene and anticipated in everything except detail the *Dovedale in Derbyshire* (*Plate 47*) (also in the Peak District) painted by De Loutherbourg in 1784. The latter concentrated on the grandeur of the gorge, losing his distance in vapour to increase the sense of its sublimity, and employing tricks like the clash of blue-green shade with yellow light to dramatize a scene inhabited only

46
ALEXANDER COZENS:
High Tor, Matlock.
1756. Oil on canvas.
Private Collection

by a few cows and a couple of figures so cunningly placed that it takes some time to discover them. It is not irrelevant that De Loutherbourg had a strong theatrical bent, painting like this is meant to provide carefully staged aesthetic titillation. People would see it and know how to respond, so far had the taste for landscape progressed. Ibbetson's disaster picture tells the same thing.

Although Cozens's picture is an early example, pictures of particular locales became prominent from the 1760s. Wilson's justly famed rendering of Snowdon (*Plates 48a and b*) is a balanced, beautiful

47
PHILIP JAMES DE
LOUTHERBOURG:
*Dovedale in
Derbyshire.* 1784. Oil
on canvas. York City
Art Gallery

48a
RICHARD WILSON:
*Snowdon from Llyn
Nantlle.* Early 1760s.
Oil on canvas.
Liverpool, Walker
Art Gallery

48b
Detail of Plate 48a

composition which acknowledges the terrain but, like the same artist's *Pembroke Castle*, uses it as an excuse for a simple yet sophisticated composition of sweeping line and muted colours. However, it does show too that Welsh landscapes were now beginning to be found of interest. Likewise Hearne, taking his watercolours to Derwentwater around 1777 and viewing the lake from the height of Skiddaw, used a similar bleak colour range for his vast and depopulated panorama (*Plate 49*). He reduced the scenery to compilations of various shapes without precise topographical identity, and composed so that we feel a precipitate drop (and are reminded of our fear of falling) to increase the sense of awe tinged with fear that we ought to experience from the grandeur of the scene.

These are instances of the extremes of uncultivated landscape, but contemporaneously artists were finding paintable motifs in rather more homely scenes. Gainsborough's *Cornard Wood*, discussed above, in setting a landscape in a wood through which runs a track established a pattern the artist was himself to develop as well as demonstrating the pictorial potential of such scenery. Indeed, as I have said, tracks through woods become almost a *leitmotiv* in Gainsborough's later, less naturalistic paintings (*Plates 61 and 62*) and seem to have prompted the aesthetic theorist Uvedale Price to record similar scenes in nature and, through his enthusiasm, presumably encourage other artists to take to the woods. Sandby in *The Rainbow* (*Plate 50*) has cattle driven through a rather less closed woodland track, behind which he has allowed a view into open country, the dramatic contrast of a rainbow against black clouds giving him a chance to show his skill as a painter of naturalistic effect.

Charting the progress of taste is a confused business, but a developing interest in landscape *as such* dates from around the 1760s, and paintings show this interest to have been wide-ranging, if not indiscriminate. Together with the fashion for medieval remains developments in landscape painting appear to run counter both to the pastoral and the georgic, the latter having been common before 1760. Here there is a connection with poetry, insofar as the unremittingly georgic poems like Dyer's *Fleece* (which details minutely the stages and benefits of the manufacture of wool and was published in 1757) also peter out at about this time (although some poets like John Scott maintain the form). Perhaps a simplified explanation for this literary and artistic trend would be that the georgic is relevant as a kind of cultural goad as a nation develops, but once it had reached the glorious state which in the view of contemporaries the Britain of George III had done, then it became superfluous.

Be that as it may, landscape painting does branch off in various directions, and the georgic for the moment vanishes. In discussing the development of landscape and the forms it assumed I have written of the audience for scenery in general increasing. I have suggested too that this audience not only desired to employ its leisure in cultivating a taste, but also needed guidance in doing so. Such guidance had been provided by writers like Burke and Reynolds who gave their readers an aesthetic jargon in which discussions could then be held, discussions which because of the arcane nature of the language in which they were couched would allow the participants to appear *cognoscenti*. More practically, some writers began to describe the kinds of country the painters were beginning to depict. Their texts were usually first circulated in manuscript amongst interested parties, and eventually published. They are genuine guide books, as against the ones which merely gave aid with planning an itinerary, and do help one make the informed response to the

49
THOMAS HEARNE: *View from Skiddaw over Derwentwater. c.* 1777. Watercolour over pencil. New Haven, Yale Center for British Art, Paul Mellon Collection

50
PAUL SANDBY: *The Rainbow*. After 1780. Gouache. Nottingham Castle Museum

scenery through which one might travel.

A literary interest in the Lake District (*Plates 49, 69 and 71*) dates from the 1750s. Dr Dalton wrote his *Descriptive Poem addressed to two Ladies at their Return from viewing the Mines at Whitehaven* in 1758. In his descriptions of the Lakes he shows that he enjoyed their landscapes.

There the brown fells ascend the sky,
Below, the green enclosures lye;

displays what the cliché terms 'a painter's eye for colour,' while elsewhere Dalton dealt with something of the motivation for visiting scenes like these:

Horrors like these at first alarm
But soon with savage grandeur charm,
And raise to noblest thoughts the mind:

It might be frightening to be in country like this, but the threat tends to be more intellectual than real, and escape is always assured. This leaves the sublimer scenes of nature to be profoundly moving, and to the eighteenth-century mind, as Dalton himself explains, this would have shown the omnipotence of God, Who was thought to have strewn these rocks and mountains around. Fields and farms might be within the reach of man and show his effect on the landscape. Country like this was beyond him. At the same time as Dalton was writing, a Dr John Brown had penned a letter on Keswick, which Christopher Hussey thought enjoyed a wide circulation before being published in 1767. Dr Brown's diction was similar to Dalton's. He was impressed by the 'rocks and cliffs of stupendous height, hanging over the lake in horrible grandeur', and by the lofty mountains which 'on all sides ... rise round ... piercing the clouds in shapes as airy and fantastic as the very rocks of Dovedale'. Interestingly, he was already in the habit of comparing landscapes, and there is a sense in which this 'horrible grandeur'' was being sought as an antidote to more ordered scenes of

cultivation (which nevertheless still held a strong attraction).

It would be part of that same shift in taste which began to find perfectly acceptable the kinds of improvement done to the grounds of country houses by Capability Brown. Although we tend to concentrate on the development of Brown's style from its prototypes in the work of Kent at Stowe and Rousham, these two parks were rather the exception than the rule, and it is fair to assume that many places still had a formal garden around the house. The great attraction about Brown of course was the low cost involved in the upkeep of one of his parks: his sweeping lawns, serpentine lakes and clumps of trees stayed in shape far longer than a parterre of ornamental flower beds, which needed constant replenishment with bedding plants as the year rolled on. A Brown park easily forms itself into a 'landscape', and such parks' undeniable popularity was part of the more general liking for less ordered scenes of nature.

Landscapes producing these sensations of pleasing horror were not confined to England. Gray, visiting Scotland (*Plate 51*) in 1765, wrote that:

The mountains are ecstatic, and ought to be visited in pilgrimage once a year. None but those monstrous creatures of God know how to join so much beauty with so much horror.

Perhaps this reaction, this turn to the wild, was to do with confidence in contemporary achievement needing to be sharpened by experiencing landscapes which dwarfed man. This was the age, after all, of the early stages of the Industrial Revolution, which at this time had something of an ambivalent relationship with these landscapes. Arkwright for instance set up the first water-powered cotton mill (an establishment which increased production phenomenally) in 1771 at Cromford in the Peak District: the paintings of Wright show this to have created a slightly disquieting

scene in which God and Mammon were clumsily juxtaposed.

While there were complex motivations for taking to the mountains, it was also an activity which quickly became simply a fashion. Sandby showed his refined ladies doing the refined thing in front of Roslin Castle, itself in a spectacular setting, and More introduced similarly relevant figures into his genuinely impressive landscape of what proved to be a popular motif, the falls of the Clyde. While he attempted to control the scene through a composition broadly like the one Richards used at Chepstow, he emphasizes how impressive it is through the spume of the falls, and the generally dark colouring. The figures react as writers had done. The males stand and admire this grand manifestation of nature, but a token woman, unable to take it all in, recoils against her protecting man: a device recalling the way the French painter David liked to have swooning women to counterpoint the masculine nobility of his heroes.

Along with numbers of paintings of rocks, waterfalls, and mountains came the rise of the Guide Book. Thomas Pennant for instance published a *Tour in Scotland* in 1771 and a *Tour in Wales* in 1778. Joseph Cradock produced *Letters from Snowdon* in 1770 and *An Account of Some of the Most Romantic Parts of North Wales* in 1777. So by the 1770s a minority taste had become a fashion. Armed with such texts, the expanding army of travellers could begin to ensure that they experienced the correct sensations at the places they visited.

As we might expect, the Peak District was one of the regions to benefit from the writers' attention. It was generally popular (*Plates 45, 46 and 57*), one could take in Chatsworth at the same time, and De Loutherbourg's and Cozens's paintings of its landscapes have been mentioned already. Edward Dayes, himself an artist (*Plate 42*), had written an *Excursion through Derbyshire and Yorkshire* (pub-

lished posthumously) and his reaction to Dovedale was probably typical: 'Delightful Dove-Dale! In Thee Nature exhibits one of the finest of her Productions! Beautiful spot!'

His profuse exclamation marks might well imitate the breathless enthusiasm of those who encountered these landscapes. All, however, was not quite so straightforward. Dayes's was, for a start, an educated reaction. Cozens's version of Matlock had been painted as early as 1756, and as we saw it did not differ in essentials from De Loutherbourg's of 1784. In the meantime Wright of Derby had begun to produce beautiful landscapes after this terrain, and it is clear that knowledge of his paintings affected in part people's reactions when actually visiting the Peak District (*Plates 56 and 57*). Writing of the Derbyshire Hills in 1789, James Pilkington opined that those 'who have had an opportunity of seeing them touched by the sweet and magic pencil of Mr Wright of Derby, will easily conceive how deserving they are of the attention that has been paid them', which returns us to a point introduced earlier, of how art confronted nature, and then nature itself came to be seen through the eyes of art. It is a species of dialectic, albeit a highly subtle one, and around the 1780s certain writers, preeminently the Reverend William Gilpin of Boldre, Hants., became aware that it was taking place.

The Derwent, which from Wright's painting of it held no terrors, ran through a landscape the quality of which had been defined by art. Thanks to Gilpin, the taste-seeking public having been instructed where to go, and how to react when there, was now led down the more esoteric avenues of aesthetic theorizing. Gilpin, a friend of both Thomas Gray and Sir Joshua Reynolds, knew more about paintings than did most people. He was also in the habit of making tours, motivated by a strong and genuine love for landscape, and as was

usual he took detailed notes, writing them up into manuscript accounts which were then circulated among interested parties. He was eventually encouraged to publish them. Gilpin broke from the basically emotional response to landscape by beginning to see it as an artist might. He discovered that scenes could compose themselves into a foreground, middle ground, and distance, and then manoeuvred himself so that the whole appeared harmonious and therefore fit for making into a picture. This of course was something like what Wright had done along the Derwent, but with Gilpin there is far more a process of judging actual landscapes according to the criteria of art. The term he invented to describe the kind of thing of which he was in search was 'picturesque beauty'. The picturesque filled a position midway between Burke's sublime and beautiful and gave aesthetic respectability to sights which were obviously neither but equally obviously productive of aesthetic pleasure. Price later defined the picturesque as being characterized visually by the conjunction of two qualities: roughness and sudden variation. Gilpin was more formal in his use of the term. In the first section of his *Observations on the River Wye* (1770) he observed that:

The following little work proposes a new object of pursuit; that of not barely examining the face of a country; but of examining it by the rules of picturesque beauty: that of not merely describing; but of adapting the description of natural scenery to the principles of artificial landscape; and of opening the sources of those pleasures, which are derived from the comparison.

He was proposing an objective and formalist aesthetic, the terminology of which was taken from the study of painting and then applied to actual landscapes. Gilpin expanded on this in his *Remarks on Forest Scenery* (1791) in arguing that he was concerned to teach people to comprehend effects distinct from their causes and therefore find pleasure in scenes of *pictorial* merit, even though they might abound with 'circumstances of *horror*'.

In his various 'Observations' Gilpin was providing more guide books, but aimed at the person visiting the place with the hope of judging it correctly as a landscape. Identification of the audience in this way again reflects on the point made earlier about the boom in art being consequent upon a concomitant boom amongst those who wished to see art. One of the things Gilpin did was to guide the judgement and make available to all a correct taste in the picturesque. That scene in *Northanger Abbey* where a discussion centres on whether or not Bath is picturesque shows that by the early nineteenth century Gilpin had inculcated a correct taste among ordinary bourgeois young ladies.

Gilpin's writing had one other result. By claiming that the picturesque was an objective aesthetic he permitted judgement of landscapes and their contents to be made irrespective of what they were. Rather than be offended by the sight of a beggar, you perceived a figure which either did or did not display picturesque characteristics, and, furthermore, was to be judged on this alone. In this way it was a means of diverting attention from reality, and in a typically picturesque landscape like Girtin's *Kirkstall Abbey* (*Plate 64*) the eye is caught as much by the brilliance of treatment, the greens and browns, the flickering lights and shades, as by the subject.

While Gilpin's books catered for a need created by the expansion in the taste for landscape after around 1760, at this period artists of the highest calibre began to take to landscape painting. While Gainsborough always considered himself a landscapist forced to drudge at portraits for a living, Wilson actually chose landscape in preference to the safety of protraiture. Paradoxically neither could sell his paintings: the demand was

51
JACOB MORE: *The Falls of Clyde (Cora Linn)*. 1771(?). Oil on canvas. Edinburgh, National Gallery of Scotland

52
RICHARD WILSON: *Holt Bridge on the River Dee*. 1762. Oil on canvas. London, National Gallery

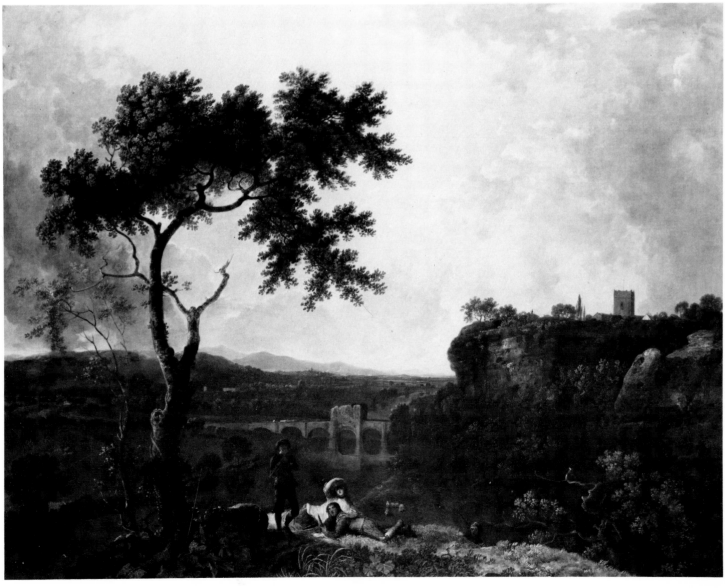

for watercolours and souvenirs, if money was to be spent it was to be on more pretentious art. Likewise, Joseph Wright painted many types of picture besides landscape. Nevertheless the landscape paintings of all three should be considered.

Richard Wilson's greatness is apparent from the quality of works like *Snowdon* (*Plates 48a and b*) or *Pembroke Town and Castle* (*Plate 37*), which have already been discussed above. He was converted to landscape while in Italy in the 1750s and was the first to return to the native scene not only with a highly polished technique, but also with a knowledge both of the paintings of artists like Claude and of the Italian scenes which had inspired them. Wilson transposed his Italianate vision to British landscapes and at times managed to conceive his paintings as mosaics of subtle colour which combined to give the effect of a beautifully lit Classical landscape. An example is *Holt Bridge on the River Dee* (*Plate 52*) of 1762, which adapts a British scene to a Claudean format. The same basic schema was used for another painting, usually entitled *On the Arno* (Southampton Art Gallery), and in a way one was an alternative view of the other. Where Wilson broke ground was in the sensitivity which led him to see British landscapes in this way: he allowed the landscape to mould itself to a preconceived pattern and produced more beautiful representations of the native scene than perhaps anyone previously had imagined (*Plate 54*). And the way he painted it also engrandized it, implying that it was a worthy subject for a Claude at a time when the latter's paintings were coming to be seen to be about nature at her most pleasant and benign. Some measure of the confusion this transposed vision could create is Wilson's painting of the ruined arch at Kew (*Plate 55*). Until recently it was thought to represent a genuine Roman ruin, and in this mistake lies the nature of the way that

Classical and contemporary British landscape became interchangeable in his work.

Wilson had little impact and finished up as Librarian to the Royal Academy. Nevertheless he did influence the direction British landscape painting was to take. For instance he introduced the practice of sketching in oils, learned from the French landscapists at Rome, and this was taken up by his pupil Thomas Jones (*Plate 53*) before becoming the regular practice of later artists. Indeed it was painters of the next generation who recognized Wilson's genius; Turner in some earlier works aped his style, and Constable professed a constant admiration for his painting. During his time, though, the age demanded something less challenging than his kind of landscape.

Likewise, Joseph Wright is mainly remembered for his dramatic scientific tableaux and his obsession with light effects or as one of the few artists we may connect with the major personalities of the earlier Industrial Revolution, rather than as a major landscape painter. However, his work in the Peak District has already featured in this account, and just to look at reproductions of his paintings

53
THOMAS JONES: *Penkerrig*. 1772. Oil on paper. Birmingham, City Museums and Art Gallery

54
RICHARD WILSON: *View near Wynnstay, Llangollen*. 1770-1. Oil on canvas. New Haven, Yale Center for British Art, Paul Mellon Collection

55
RICHARD WILSON: *Kew Gardens, the Ruined Arch*. 1762. Oil on canvas. Collection of Brinsley Ford

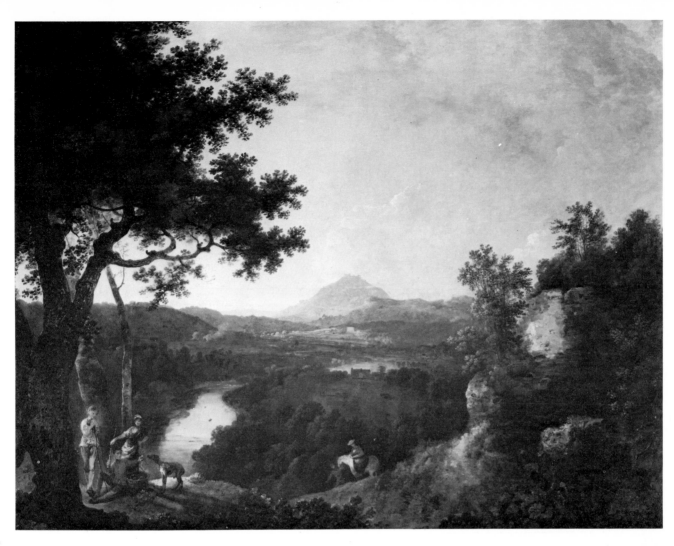

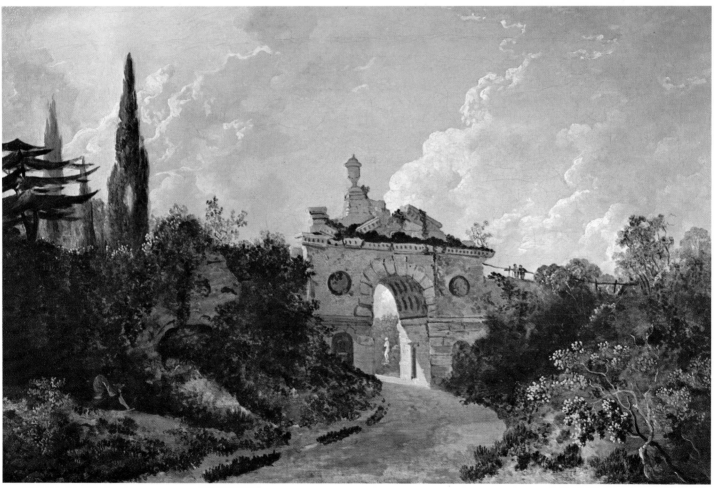

assures one of the quality he could reach. His landscapes in general date from the 1780s, although the *Earthstopper on the Banks of the Derwent* predates them (*Plate 57*). This 1773 canvas displays the artist's almost pathological concern with opposing light sources and their effects on their surroundings. Here the cold and eerie light of the moon contrasts with the lamp's warmer and more limited glow. Unusually for the time Wright also takes up a georgic theme, the rural sport of fox-hunting, and illustrates the preparations for the day as the labourer ensures that the hunted beasts will find no avenues of escape. However, it could not be said that the subject is strictly relevant to an appreciation of the composition and despite its near contemporaneity with Stubbs's four paintings of a day's shooting (New Haven, Yale Center for British Art) Wright probably chose the subject because it allowed him to depict opposing light sources in a naturalistic setting.

Matlock Tor, Daylight (*Plate 56*) lacks the histrionic element of other Peak District landscapes, and its dry and even paint surface gives the impression of an equal focus over everything. There is a brave attempt at getting the effect of looking into the light with the sun behind a cloud, past the fringes of which burst its rays. Tiny figures and a small hut create a sense of scale to recall the drama which others emphasized, but this is a more subtle drama, and while being symptomatic of the taste for the Peak District, paintings like this also defined and spread it. Others are of startling brilliance (*Plate 60*). Although his picture of a river with a rainbow could be considered in terms of conventions, the picturesque, or the influence of Rembrandt, or even as another study of light, it is still a remarkable and beautiful painting, and it does to remember this.

Many of Gainsborough's landscapes, too, are conspicuously beautiful: Constable called them 'soothing, tender, and

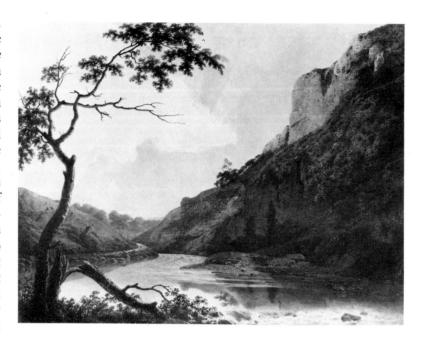

affecting', and only in Gainsborough's paintings of the 1760s do we see any trace of the rustic themes so prevalent until the 1750s. Gainsborough's landscapes deserve long contemplation. The Suffolk ones are easy and fluent and take pleasure in the world. In the small canvas showing a peasant leaning on his stick outside his hovel in the company of two asses and a dog (*Plate 58*) all is harmonious. The man's ugliness is as unexceptionable a fact as the form of the tree, and various scattered motifs signify the balance of his country life. He lives in a hovel, owns a couple of donkeys, and works a plough, which he has now laid by to engage in contemplation. The landscape is sandy and rutted and the village behind (shown up through the church tower) gives his existence a social point. This sense of harmony between man and landscape (*Plate 59*) vanished shortly after Gainsborough reached Bath. Obviously one might expect the actual forms of his landscapes to alter, for Somerset is hillier and more wooded than Suffolk and the husbandry there was geared far more to stock; but nevertheless the change cannot be wholly explained by the move.

56
JOSEPH WRIGHT:
*Matlock Tor,
Daylight*. Mid 1780s.
Oil on canvas.
Cambridge,
Fitzwilliam Museum

57
JOSEPH WRIGHT: *An
Earthstopper on the
Banks of the Derwent*.
1773. Oil on canvas.
Derby Museums and
Art Gallery

58
THOMAS
GAINSBOROUGH:
*Peasant and Donkeys
outside a Hovel*.
1755-7. Oil on canvas.
Private Collection

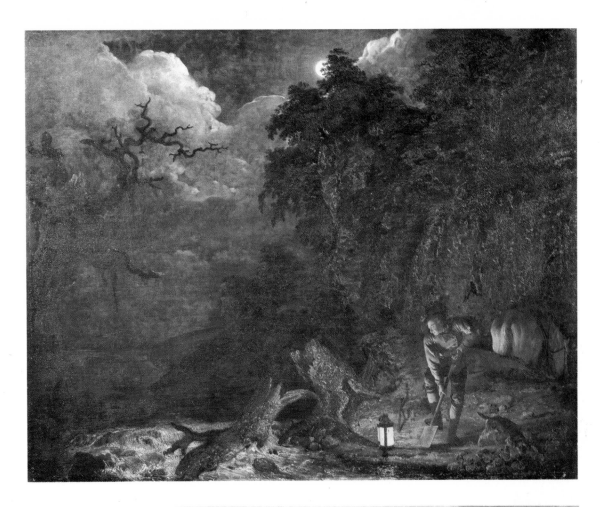

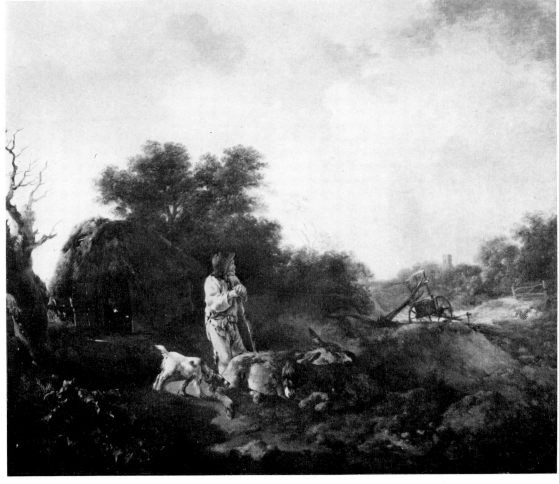

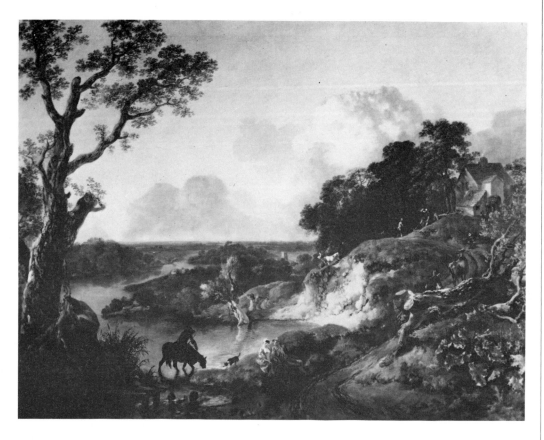

59
THOMAS
GAINSBOROUGH: *River
Landscape with Horse
Drinking and Rustic
Lovers.* 1754-6. Oil on
canvas. St Louis Art
Museum

The painted terrain does become hillier and more wooded, but also begins to fill with images of migration. Gainsborough's figures are often on the move, and their travelling is less logically defined than that of his Suffolk peasantry. Once we have torn our eyes from the seductively beautiful painting of *The Road from Market (Plate 61)* we cannot tell whether these figures are going to or coming from somewhere, and they look neither contented nor settled. Likewise *The Harvest Wagon (Plate 62)* asks more questions than it actually answers. Leaving aside the question of whether the figure group derives from his study of Rubens's *Deposition* (the comparison is not satisfactory), we see the figures stopped in an unlocated landscape, the finery of the women clashing with the scruffiness of the men, the latter obviously workers. It seems odd that these people should mingle, as it also seems peculiar that one figure can control the horses with such little effort. The limpid colouring and lack of any clear connection of the painted with the actual forms of landscape increase the jarring of the reality of the peasant striving for beer and the artfulness of the country in which they are stopped. It may be that Gainsborough was inventing a pastoral world rather than showing, as he had done in Suffolk, a real one, because he was unable to extract meaning from what he encountered on his rides around Bath. His emphasis on travel or migration correlates with the migration of the settled rural community, which is so strong a theme of *The Deserted Village*: the old country world has been destroyed, this is one of the ways we know it. Equally the diversion of artistic attention to other scenes and the creation of systems like the picturesque which allowed one to judge the merit of an object no matter what its

60
JOSEPH WRIGHT:
*Landscape with a
Rainbow. c.* 1794-5.
Oil on canvas. Derby
Museums and Art
Gallery

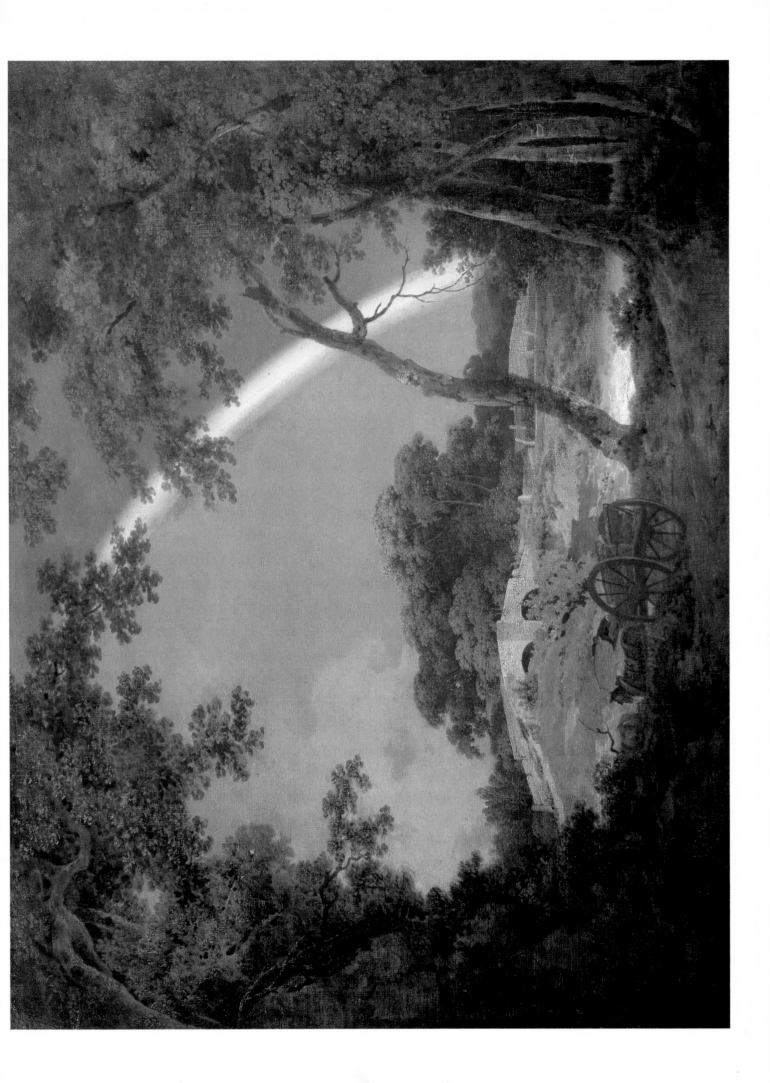

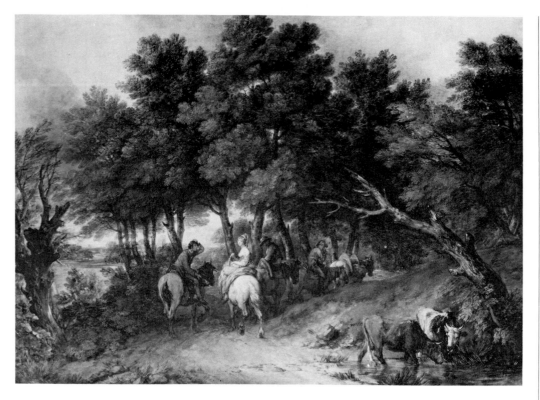

identity, may have been partly an attempt to fill the gap which this decline in paintings of rural life had created; although for reasons to be given in the next chapter it revived around the 1780s.

Gainsborough's later pictures show a retreat from the real world. His *Mountain Landscape* (*Plate 63*), while taking some inspiration from a 1783 tour to the Lake District, is also the picture of an imaginary world. Gainsborough used to construct surrogate landscapes in a box, using coal for rocks, broccoli for the

trees, broken mirror for water, and back-lighting it all with candles. Once we are let into the secret, it becomes hard to resist breaking the paintings back into their constituent factors. Gainsborough's work makes an interesting contrast with Wright's contemporary and unblinking confrontation with the facts of the Derwent Valley (*Plate 56*). To hold up these paintings together only serves for the last time to stress the diversity of British landscape painting after the late 1750s.

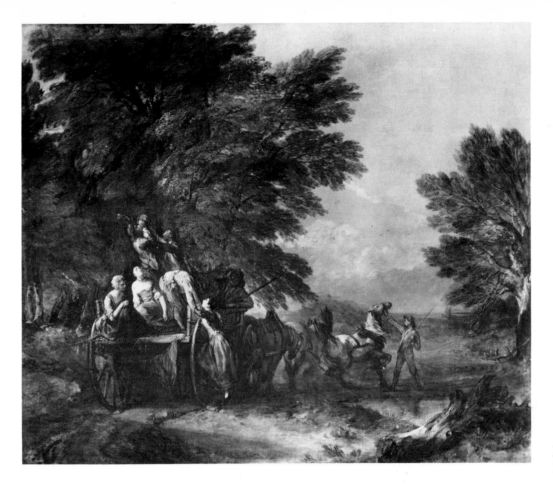

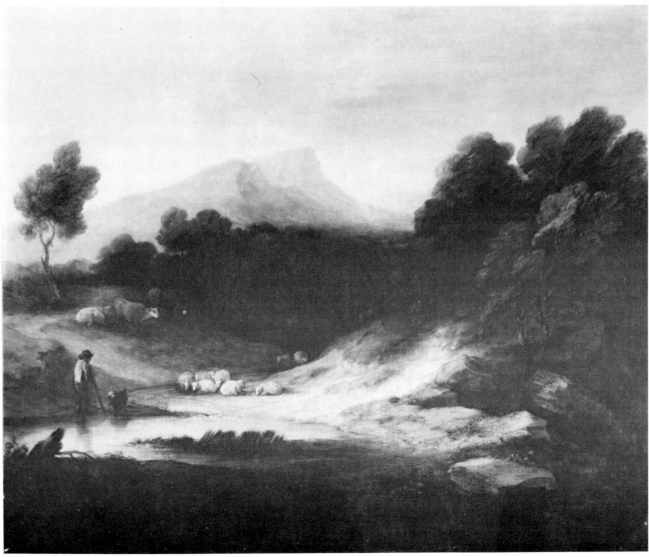

4 Romanticism and Reaction

The historian's division of time into periods can be an arbitrary process, governed by convenient dates like the reigns of kings or the starts of wars, while change actually tends to be gradual. In the last chapter paintings done outside the chronological limits cited were mentioned to illustrate more specific points, and the period from about 1790 sees painters develop the landscape interests discussed there, although the treatment of them begins to vary. And, of crucial importance, over these years landscape becomes the idiom chosen by great artists.

For example, the lure of the medieval remained fairly constant. Girtin's *Kirkstall Abbey* (*Plate 64*) is worth comparing with Cotman's virtually contemporary *Croyland Abbey* (*Plate 65*) to see two painters of genius studying similar motifs to different ends. And other manifestations of this interest are Cotman's *Byland Abbey* (*Plate 66*) and Bright's rather later *St Benet's Abbey* (*Plate 67*). Girtin's view concentrates (as we have said) on the forms of the landscape and the way that the motif can be incorporated into a general pattern of light and shade. This inevitably means that there is some simplification, the artist choosing to emphasize some things at the expense of others, but by so doing he has carried out his limited brief with conspicuous success. It is the formal calibre of the work which is so striking, the just management of colour, the subtlety of composition, and this bespeaks too an interest in exploiting the medium, shared by Girtin's friend Turner. A watercolour's translucency allowed washes to be laid over washes so as to create either highly defined or vague areas in a composition. Sandby and the younger Cozens had first exploited the medium, but Girtin and Turner were virtuosos with it. The latter is said to have treated watercolour like oil and vice versa: a far cry from using it merely to fill in outlines with general indications of the hues of the objects represented.

Girtin loses the element either of veneration for the medieval or of its inspiring the mind to ideas of the nobility of ancestors, and uses the abbey as a convenient and conventional picturesque motif. In *Croyland Abbey* Cotman also divested the ruin of blatant signification. He turned it into a virtually monochrome silhouette, mixing his pigments to create effects whereby parts of the architecture blend into the stormy sky passing over from the right. In front has been placed a solitary figure. It is hard to avoid the word 'romantic' in contemplating the painting: it seems to be an *intrinsically* threatening and melancholy image, not one that achieves its effect through content. Like Girtin, Cotman stresses not so much the symbolic aspect of ruined medieval architecture but uses it as a motif to which we can respond in any way we choose.

This has some connection with the breakdown, about this time, of commonly agreed critical rules. Words-

64
THOMAS GIRTIN:
Kirkstall Abbey. 1802.
Watercolour. London,
British Museum

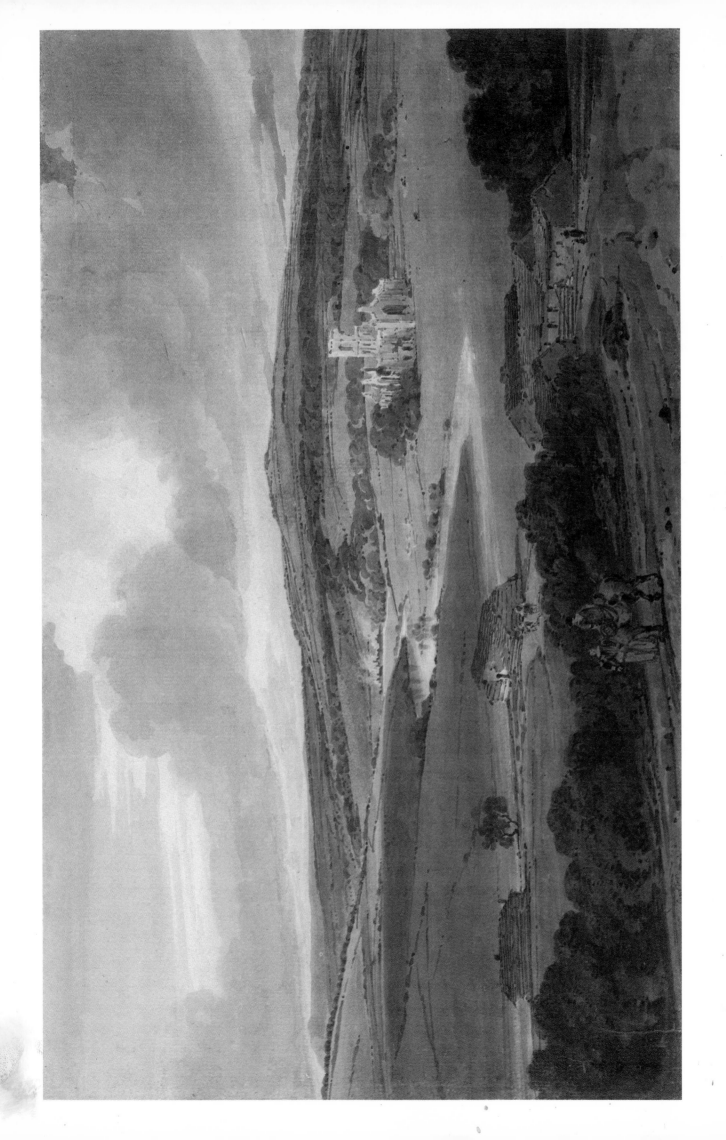

worth, in the *Preface* to *Lyrical Ballads* explained that:

The principal object ... was to choose incidents and situations from common life...and, at the same time, to throw over them a certain colouring of the imagination...and above all, to make these incidents and situations interesting by tracing in them, truly though not ostentatiously, the primary laws of our nature...

His *a priori* assumption was that by contemplation the individual could unravel eternal truths. Previously these had been thought to result from experimentation and discussion, and accordingly to have been demonstrably self-evident. With Wordsworth there is a new element of intuition, discerning the philosophic structure which regulates the universe through instinct rather than reason, and along with this there is an emphasis on the role of the individual. Of course any group of individuals seeking to intuit the nature of the universe is likely to come up with a variety of explanations, as the equal variety of outlook amongst painters and writers at this period is evidence enough. There was no longer common agreement on the nature of the universe as a machine, and as Morse Peckham has stated in a brilliant essay, 'more and more, thinkers began searching for a new system of explaining the nature of reality and the duties of man'. He writes too of the failure of reason forcing people into apprehending the truth 'intuitively', as Wordsworth said he was attempting in *Lyrical Ballads,* where he tried by transcribing what he saw as valuable in rural life, to embody some form of eternal value in his poetry: this is the kind of thing he means when he writes of 'primary laws'. It is the shift of taste from the consensus to the individual which denotes romanticism, and instead of conceiving of a 'romantic movement', it is rather that there is a period in history when for various reasons individuals become romantics in the sense described above.

Hence Girtin and Cotman take a type of landscape motif which a decade previously would have been perfectly amenable to historical decoding and empty it of most of its content. Nevertheless historical constraints do intrude. Cotman did other pictures of medieval architecture and we can discover his motivation for this by learning about his circumstances in East Anglia, and realizing that one of the ways he tried to earn a living was through publication of prints after works like this. So, in a contradictory way, he ties into the tradition of illustrating popular monuments and remains, although he is now in a position where he can take for granted their propriety as painterly motifs and exploit them for more personal artistic concerns. If we contrast Cotman's abbeys with Henry Bright's painting of St Benet's Abbey — so decayed that it almost loses its ecclesiastical identity in supporting a windmill — various other factors appear.

For example, Cotman and Bright had been personally associated in the group we call the Norwich School. The Norwich Society had begun in 1803 and held exhibitions from 1805. Trevor Fawcett has pointed out how remarkable this is: in 1800 the only British art institutions had been in London and Dublin. By 1808 they existed not only at Norwich, but also at Bath and Edinburgh. Bristol also contained distinguished painters (*Plate 102*).

Decentralization would follow naturally from the expansion of the audience for painting and the development of the British School. Edinburgh and Bath could both lay claims to be cultural centres, and Norwich, a manufacturing city, had a large enough section of polite society to support exhibitions of painting. Indeed they were held into the 1820s, although the Norwich Society was eventually weakened by the bankruptcy of Crome and the removal of major figures like Cotman to London. Rather than providing an alternative to

65
JOHN SELL COTMAN:
Croyland Abbey. 1802.
Watercolour. London,
British Museum

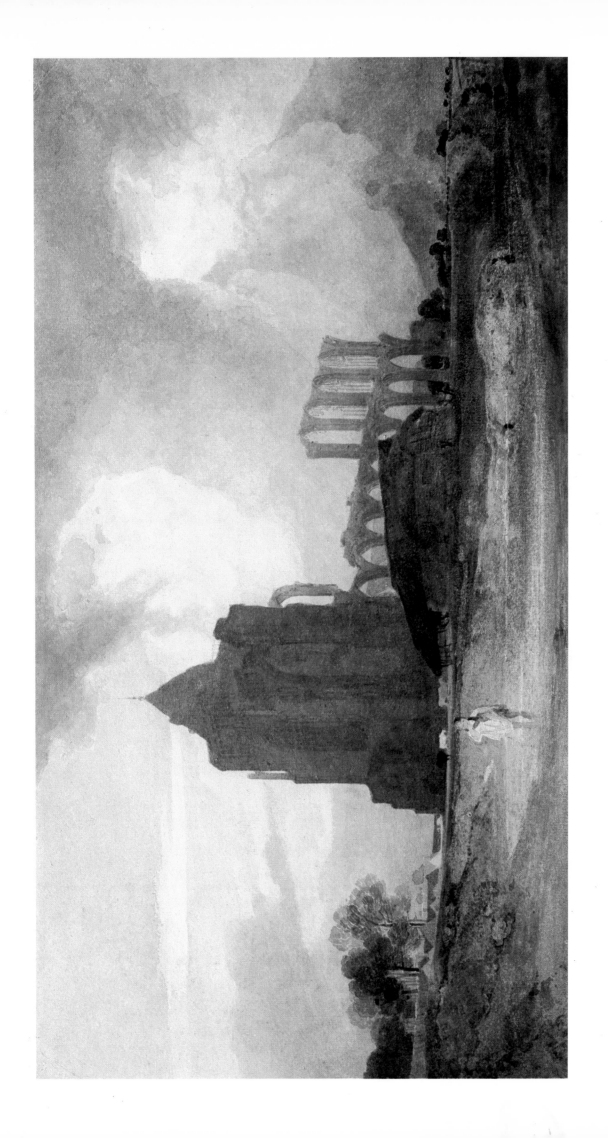

London exhibitions, provincial ones reflect the growing strength of bourgeois cultural aspirations, a feeling that the provinces could prove their own worth by following the metropolitan pattern. The prospectus for an *East Anglian Magazine* in 1813 claimed for instance that the area yielded 'not in wealth, intelligence, or liberal curiosity, to the inhabitants of any other portion of the empire'.

So the geographical association of Cotman and Bright means that their pictures might show subjects thought generally interesting to their local milieu, and certainly in national terms they were hardly unusual. Their work demonstrates also how artists of varying talent would approach their motifs differently, another instance of the various interpretations the romantic attitude permitted. Bright is interested in ruins but makes his point through picturesque devices, explaining the image by reminding us of art. The strong chiaroscuro brings to mind the paintings of Rembrandt, and this formal association is meant to invest Bright's picture with some of that master's gloom and grandeur. Equally the general treatment, and the portrayal of a flat landscape punctuated vertically only by the abbey and windmills, is generally reminiscent of some of the work of Jacob van Ruisdael. So Bright emphasized the drama by connecting his painting with earlier art, and by referring to a tradition of painting then held to be of considerable worth, hoped to take over some of that worth himself.

Medieval remains then remained attractive, although artists had begun to treat them differently. Painters also continued to visit sublime and once terrible scenery, but so familiar had it become that Ibbetson used a picturesque torrent opening out into a pool as a setting for a lascivious display (no doubt to be leered at in some male-only enclave) which is coyly entitled *The Mermaids' Haunt* (*Plate 68*). Like any good second-rater (Wheatley is another), Ibbetson's paint-

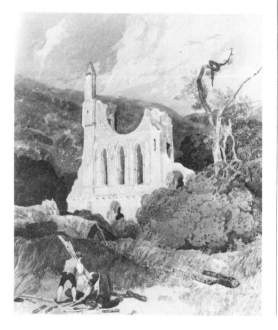

66
JOHN SELL COTMAN: *Byland Abbey. c.* 1809. Pencil and watercolour. Norwich Castle Museum

67
HENRY BRIGHT: *St Benet's Abbey on the Bure. c.* 1845. Oil on canvas. Norwich Castle Museum

ing reflected fashion rather than starting it. A piece of light pornography in a picturesque setting denotes the ultimate acceptance of the wilder landscape, and we saw his catalogue of Welsh accidents (*Plate 44*) functioning as an illustration not only of what happened when you went touring, but also, of who actually underwent these tribulations.

Certain places began to take on the quality of shrines, where worshippers, armed with the appropriate volume of

68
JULIUS CAESAR IBBETSON: *The Mermaids' Haunt.* 1800. Oil on panel. London, Victoria and Albert Museum

Gilpin, could go to commune with nature. In a way they had now become common property. The Wye valley was archetypically one of these *loci classici*. It was easy of access — one made one's way down to Gloucester and then along to Ross — and one could sail down it, disembarking at various strategic points. Furthermore, close by were interesting ruins like the castles at Goodrich and Chepstow, from which extensive views over the countryside were to be had, and a Wye trip could very conveniently be combined with a further excursion to experience the sublimities of the Welsh mountains.

Richards's *Chepstow Castle* was an earlier illustration of this region, while in 1805 De Loutherbourg depicting the Wye at Tintern Abbey (*Plate 70*) appealed loudly for public approbation. The ruins themselves are artfully hidden so that the eye has the pleasure of the search besides wondering at the cleverly picturesque colour combinations. A painting like this takes no risks. It was sure of a market and did not present many problems of comprehension.

De Loutherbourg was not alone in promoting a selling line (*Plate 69*). In a diary entry in 1807 Joseph Farington observed that Reinagle, an artist famous for his eye to the main chance, 'in consequence of the great success of Glover in selling his drawings of views of the Lakes is gone to that country accompanied by *Havil* to store themselves with subjects for drawings'. That very few today will have heard of either artist is some proof of the journeyman nature of this activity.

Neither did De Loutherbourg take any chances with his picture of Tintern. Gilpin of course had established this spot in 1717 as one of conspicuous beauty. A 'more pleasing retreat could not easily be found' he wrote of Tintern, calling it 'the most beautiful and picturesque view on the river'. Unfortunately, when turning his attention to the Abbey,

he found that the regularity of its gable ends was to its detriment as a picturesque object, although a 'mallet judiciously used (but who durst use it?) might be of service in fracturing them'. Gilpin's confident appropriation of the landscape would have encouraged both artists and travellers to visit these scenes, and this accounts for the proliferation of picturesque landscape in general. Despite its fashionable popularity, however, the Wye could still inspire profound emotion. In 1798 Wordsworth wrote that:

> Once again
> Do I behold these steep and lofty cliffs,
> That on a wild secluded scene impress
> Thoughts of more deep seclusion...

a few miles above Tintern, deploying his facility in descriptive terminology, and again hinting at the idea of certain landscapes having become common property, almost as though the reason for their existence was to benefit travellers in search of the picturesque or the sublime.

The kind of direct engagement between an artist and the scene painted, most obvious in Gainsborough's topographical georgic of his Ipswich days, becomes rare, and the necessity to contemplate the world as a series of painterly motifs, with which one had no practical connection, means that any meaning they might have had became diffused. (*Plates 69, 71-4, 76*). They were fast on the way to becoming accredited beauty spots. Touring was satirized on these terms in a comic opera *The Lakers* in 1798. It describes current events in the Lake District.

> Each season there delighted myraids throng,
> To pass their time these charming scenes
> among:
> For pleasure, knowledge, many thither hie,
> For fashion some, and some — they know not
> why ...

It is fascinating how scenes which forty years previously had been 'horrible', have now become popularly acclimatized to 'charming'. The artistic consequences of the rage for touring can be learned

69
PHILIP JAMES DE LOUTHERBOURG: *Lake Scene in Cumberland: Evening*. 1792. Oil on canvas. London, Tate Gallery

70
PHILIP JAMES DE LOUTHERBOURG: *The River Wye at Tintern Abbey*. 1805. Oil on canvas. Cambridge, Fitzwilliam Museum

from an 1810 report on the annual Spring Gardens watercolour exhibition in *Ackermann's Repository*:

In pacing around the rooms, the spectator experiences sensations somewhat similar to those of an outside passenger on a mailcoach. Mountains and cataracts, rivers, lakes, and woods, deep romantic glens, and sublime sweeps of country, engage his eye in endless, and ever-varying succession.

And one of the running jokes in *Headlong Hall* (1816) is Milestone the landscape gardener's seeking to improve the picturesque grandeur of the Welsh landscape into insipidity: Peacock's expectation of this joke being understood and enjoyed also points to a taste for mountains having become diffuse.

Great artists however can always feed from clichés and turn them into something rather more impressive. J.M.W. Turner was a dedicated picturesque tourist and in 1798 showed among other sublime landscapes one of *Buttermere Lake and part of Cromackwater* (*Plate 75*) at the Royal Academy. Far from mere delineation, Turner, working almost in monochrome, exploited the gloom of passing showery weather to lose his forms in an indistinctness which fosters a sense of foreboding. By not detailing the size of the mountains in terms of the familiar dimensions of trees in the middle distance, he created a sensation of vastness; the sublimity of Hearne's earlier watercolour of the view from Skiddaw (*Plate 49*) appears tame in comparison.

Turner, probably the greatest of all British painters, was a landscape specialist. This testifies that landscape (along with the inescapable portrait) had become the natural idiom for British artists. True, there was a market for genre painting, in which Wilkie was unsurpassed, and there is a type of painting where the genre element jostles for attention with the landscape part. Despite all this, landscape had become firmly es-

tablished, and there had begun to develop a system of practice. Reinagle saw profit in a tour to the Lake District; Turner was typical in setting off most summers to some picturesque region, making large numbers of sketches and drawings, and then during the winter months he used these as the basis for painting large works intended for exhibition. The only exception was Constable during the years 1808 to 1817, when he concentrated on the scenery around the family home at East Bergholt. Even the Norwich School artists were itinerant, and Rowlandson celebrated an instantly knowable type in his portrayal of a glum and laden artist on an equally miserable nag plodding through a characteristic Welsh storm.

Along with picturesque touring becoming so common as hardly to rate notice, the period from 1800 is also that when oil sketching from nature comes into its own, and I shall deal with this below in the context of paintings of native scenery during the Napoleonic Wars — painting which is intimately connected with a powerful revival of agricultural landscape. And as this genre had begun to reappear during the 1780s, it is now necessary to pass back a few

71
EDWARD DAYES:
Haweswater, Westmorland. c. 1795.
Watercolour over pencil. New Haven, Yale Center for British Art, Paul Mellon Collection

72
CORNELIUS VARLEY:
Landscape in North Wales. 1805.
Watercolour. Collection of the Marchioness of Dufferin and Ava

decades and to consider its history from
that time.

In terms of that earlier discussion of
romanticism, contemporary agricultural
landscape painting is strongly anti-
romantic. The very fact of its having an
iconography indicates that the readings
given to its subjects are the consequence
of agreement amongst numbers of peo-
ple, rather than one artist intuiting that a
ploughman might serve as a figure for
abstracted Industry. Agricultural land-
scape took a view of the countryside and
country life in which incidents retained
their traditional roles. In terms of loca-
lized landscape they indicate that healthy
state of the nation the georgic had pre-
viously signified for the Augustans. But
in creating this idea of the British scene,
painters took a selective view. The paint-
ings rely on an aesthetic agreement on
the part of artists and public wishing to
see the countryside and life therein as
favourably as possible. Thus the genre
stood to lose credence if it was seen to lie,
if, for instance, the ploughman declined
his role as Honest Industry by behaving
incompatibly with it. Notwithstanding
this, a majority still enjoyed the sight of
the busy scenes of husbandry; in 1791
Gilpin complained of the habit of calling
pleasing a country which comprised
'hay-cocks, or waving corn-fields, or
labourers at their plough ... which the
picturesque eye always wishes to ex-
clude'. The picturesque depended on
formal criteria only. Because agricultural
landscape was commonly popular, its
reappearance in painting must have
some connection with this simple fact.

Francis Wheatley, like Ibbetson, is
another painter whose works give a fair
indication of which way the wind of fash-
ion was at any one time blowing. In
1774 he painted *The Harvest Wagon*
(*Plate 77*), a free paraphrase of
Gainsborough's painting of 1767 (*Plate
62*). This raises certain points. Not the
least is that Wheatley must have sensed
that a pastoral landscape might well be

worth exploiting. *The Harvest Wagon* is
an important indication that interest in
rural scenes was reviving. A comparison
shows that he made significant changes
from the model. Like Ibbetson, or De
Loutherbourg, Wheatley had a fluid,
rather Rococo style, which gives painted
objects an appearance of solidity, cer-
tainly contrasting with the feathery
effects of Gainsborough's mannerism.
The landscape itself was also more of this
world than Gainsborough's. In the fore-
ground is a cart full of rustics, halted on
a conspicuously picturesque track to
decide whether they have space for a
traveller who is pointing out his direc-
tion. We can admire the skill with which
Wheatley has dealt with the twisting
trunk of the ruined oak at the side, or the
management through various *coulisses* of
the composition to draw the eye irresis-
tibly into a rich distance. These are real
labourers going about their business in a
landscape which gives their existence
point. The ruts show that the track is
much used, and the anecdotal factor
introduced by the pointing traveller
clears up the questions about destina-
tion raised by Gainsborough's original.

73
CORNELIUS VARLEY:
*Llyn Tally Llin at my
Back. c.* 1802-5.
Watercolour over
pencil. New Haven,
Yale Center for
British Art, Paul
Mellon Collection

74
JOSHUA CRISTALL:
*Sunset with Fishing
Boats on Loch Fyne.
c.* 1807. Pencil and
watercolour. Oxford,
Ashmolean Museum

76 GEORGE ROBSON: *A Highland Landscape*. c. 1830 (?). Watercolour. New Haven, Yale Center for British Art, Paul Mellon Collection

The girls are pretty and the standing male handsome, and we receive a reassuring impression of a rude and healthy peasantry, rather than being disquieted by the conflict in Gainsborough between over-dressed fashionable women and thirsty and ragged boors.

Indeed, in a way Wheatley's picture is a detailed critique of Gainsborough's, and in producing an image more to contemporary taste he suggests what it was about Gainsborough's landscapes which made them unpopular.

The figures are idealized here. This was even more the case in Westall's *Storm in Harvest* (*Plate 78*) exhibited at the Royal Academy in 1796. It shows a touching scene as reapers shelter from a terrifying storm under a tree. But the painting does have flaws; or at least it does from the point of view of the countryman, who will be expected to be familiar with such scenes. The poet Robert Bloomfield, famed for *The Farmer's Boy* (1800), which described the life he himself had known on the farm, went along to see the painting. He thought that 'the sheaves, whether meant for barley or wheat, are a bad crop', one imagines as a consequence of Westall's ignorance of country matters, and was astonished to find that 'the man and woman in the foreground are sitting *facing* the weather?' So prosaic an approach to a work of *art* may have been missing the point, but Bloomfield's criticism hits on one main ingredient of pictures of this kind. In a way they equated with history painting in illustrating a fiction, and satisfied a demand for such images. Figures like Wheatley's or Westall's were originally a literary creation and appeared in much the same guise through numerous poems, from some written before *The Seasons* to the end of the eighteenth century, notwithstanding the protestations of Crabbe in *The Village* (1783). We find them populating not only such efforts as Dodsley's *Agriculture* (1754), but also pastorals like Shenstone's, which des-

77
FRANCIS WHEATLEY:
The Harvest Wagon.
1774. Oil on canvas.
Nottingham Castle
Museum

78
RICHARD WESTALL:
Storm in Harvest.
1796. Oil on canvas.
Payne Knight
Collection

cribed an ostensibly contemporary rural life. These poetic rustics are always swains rather than louts, they are invariably ruddy with health and always cheerful. Their women are nymphs, and only age gives a slight tarnish to their fresh beauty. With the increase in the

79
THOMAS ROWLANDSON:
Landscape, Cattle in a Stream. c. 1795-1800.
Pen and watercolour
over pencil. Oxford,
Ashmolean Museum

sizes of towns noticed by Wordsworth in the *Preface* to *Lyrical Ballads* the metropolitan audience may have begun to yearn for an image of the country life it thought it had left behind — Raymond Williams has written how every generation yearns for the better life their ancestors knew in the country, and it ought to be noticed that its expression by Goldsmith in *The Deserted Village* was partly a response to contemporary social developments. In the later eighteenth century this nostalgia would have had an extra cultural load, for one of the georgic conventions was to contrast the innocence and health of country life with grimy urban existence, and to hold up the former as the desirable ideal. Hence painters could churn out images confirming this and at the same time connecting with enough observable fact to make credible the notion that what they showed could well be real.

From time to time, for example, Rowlandson produced amiable recastings of Gainsborough (*Plate 79*). And although his fluent calligraphy presents his images at one remove from realism, we accept it as the medium through which he transmitted what he actually saw in the countryside. Unlike Gainsborough he does not posit an alternative reality. Rowlandson's imagery is bucolic, the country is the place to live, and there is no feeling that peasants like his would ever need to do anything other than watch a herd of cows amble through a stream. This country life is richly pleasing. The same, with reservations, goes for some of the work by Thomas Hearne. His delightful watercolour entitled *Summertime* (*Plate 80*), washed in with pale and subtle colours, features a swarm of pretty maidens and elegant swains effortlessly making hay, an extensive landscape stretching out behind them. In common with earlier versions of the subject, there is a sense of crowding and of light-heartedness although, unlike those of, for example, Dixton's

Haymaking, these figures never existed except in Hearne's imagination. Significantly, he is expecting this conventional georgic iconography to be understood (haymaking is even acting in the time-honoured way as indicator of season). The image is a reassuring one in the reactionary sense which says that one should not be disturbed by such freaks as Arkwright's cotton mill on the Derwent for the old standards stayed the same.

Hearne ploughed the same furrow with some designs etched by Byrne and published in 1780 (to be reissued in 1810) as 12 prints under the heading 'Rural Sports' (*Plate 81*). As our example shows, these were distinguished works of art. And as the sequence was broadly seasonal, they made a fascinating modern counterpart to the medieval Labours of the Months. Furthermore, because they were prints, meant to sell cheaply to a large number of purchasers, we can be sure that this kind of imagery maintained a popular appeal. Hearne's designs link into that artistic chain which in Britain is revived with the work of the Dutch and Flemish Prospect Painters.

The major exponent of rustic landscapes at this period, however, was George Morland (*Plates 82 and 83*). Both examples typify the work he would turn out at amazing speed so as to keep himself in gin. Despite the slapdash character of much of his painting when the circumstances of production demanded that he fudge detail if at all possible, it is also true that he knew and liked the subjects he purveyed, and would never have made errors of the kind that Bloomfield detected with Westall. His *Bargaining for Sheep* (*Plate 82*) shows, like *Ferreting* (*Plate 83*), a typical incident of rustic life. In the case of the latter it may take some time to realize that the subject is socially ambiguous, for besides being one of the standard ways of clearing warrens, ferreting is also a time-honoured poaching technique. At this period the punishments for poaching were ghastly, and

80
THOMAS HEARNE:
Summertime. 1780-4.
Watercolour.
Manchester,
Whitworth Art
Gallery

81
W. BYRNE (after
Thomas Hearne):
Ploughing from 'Rural
Sports'. Engraving,
published 23 July
1810. London, British
Museum

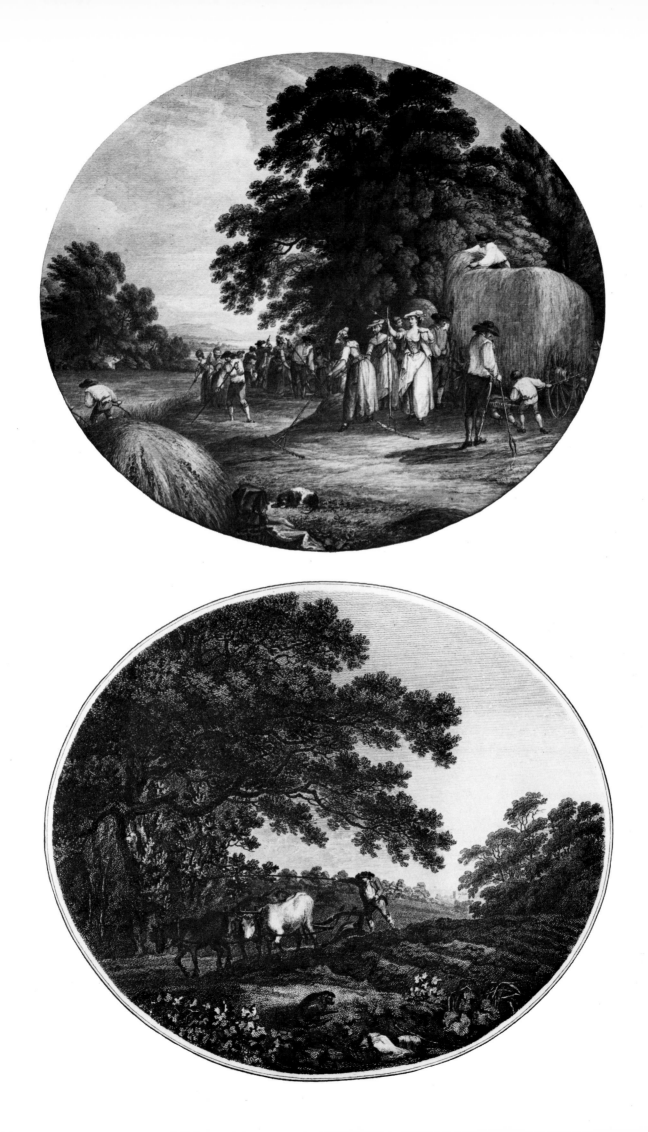

such a painting, if it were thought to portray thieves, would have disturbed contemporary critics. Of this we can be sure, because Morland managed spectacularly to do this with some of his other works.

Morland is as well documented a painter as any other of the period, for the simple reason that his life was of such spectacular and anarchic profligacy that as soon as it was prematurely terminated in 1804 biographies began to appear in the hope of appealing to a sensation-seeking market. The remarks his biographers made on his painting are often revealing as to the unwritten constraints on rural subjects. Collins found the girls in the cart in a *Return from Market* 'rather too brazen for rural nymphs': he expected rural nymphs to be closer to what Wheatley or Hearne painted, not representations of people. And he condemned a picture called *The Ale-House Door* because it showed:

A group of English figures regaling themselves, which, like true sons of liberty, they seem determined on in spite of all opposition.

In his exemplary discussion of Morland's work, John Barrell has pointed out how much this passage reveals of actual attitudes to the poor. It is well to remember that Collins was writing in 1805, in the middle of the war, and one of the things which had caused this war was the popular overturn of rightful government in France in the name of Liberty. There was a strong fear that this might happen in Britain too. He clearly did not like a painting which showed rustics sitting around drinking when they ought to be at work. They are doing it in spite of all opposition and they can get away with it only because they are English (rather than French), and accordingly 'true sons of liberty'. He really had to stretch the myth to accommodate his disquiet.

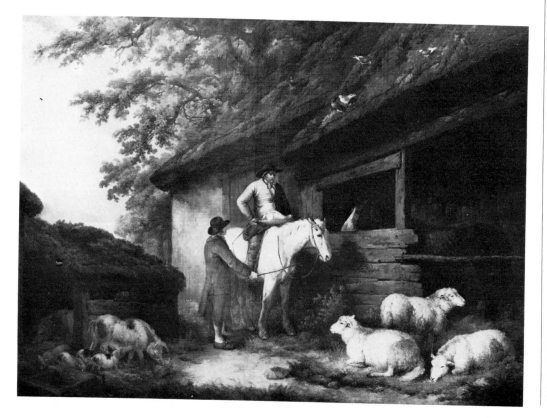

82
GEORGE MORLAND:
Bargaining for Sheep.
1794. Oil on canvas.
Leicestershire
Museums and Art
Galleries

83
GEORGE MORLAND:
Ferreting. 1792. Oil on canvas. Private Collection

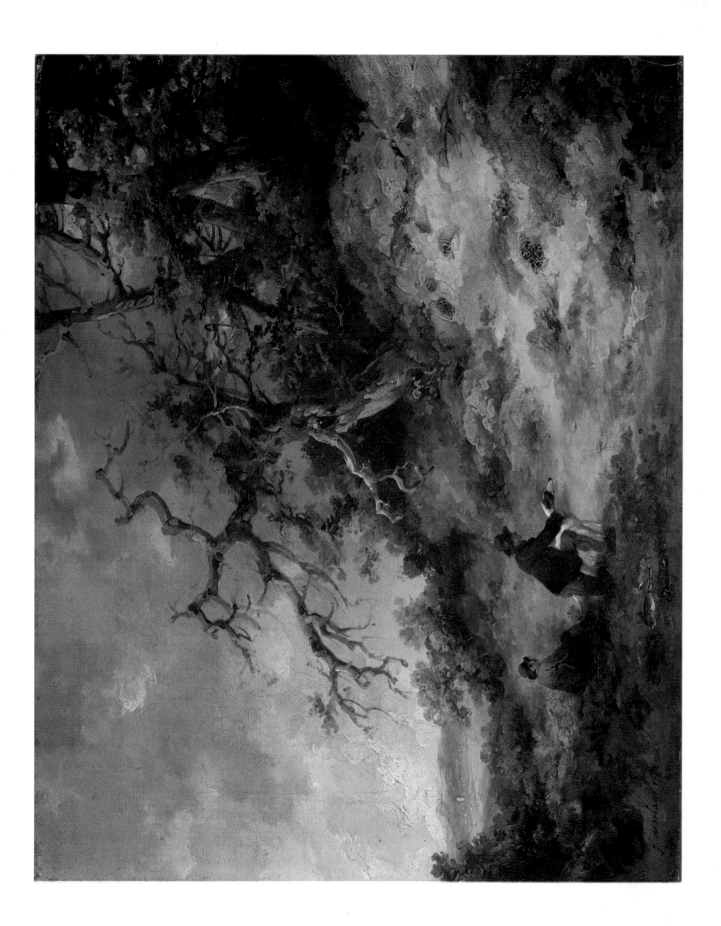

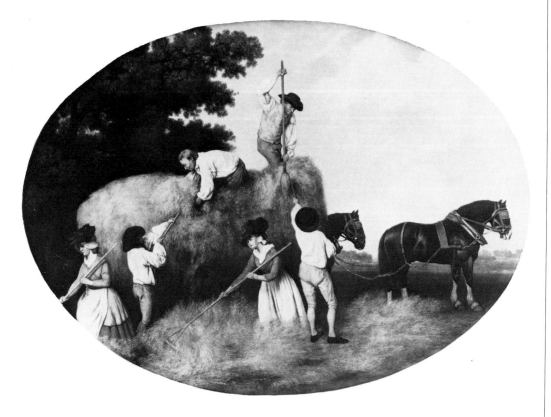

84
GEORGE STUBBS:
Loading Hay. 1794.
Enamel on a ceramic
plaque. Port Sunlight,
Lady Lever Art
Gallery

Collins does show too that art could approach too close for comfort. The ideal, what Hearne shows, could not fail to please. Morland's paintings can jar. The period from 1784, when Arthur Young first published the *Annals of Agriculture,* is conspicuous for the quantity of writing produced on all aspects of agriculture. There was a concern to increase productivity, in which regulation of the work force was a key factor. Writers stress the necessity to 'regulate' the poor towards habits of honesty, industry, and sobriety (left to themselves, presumably, they would be drunk, lazy, and thieving) and distrusted the capacity of the poor to keep their side of a tacit bargain to better everyone's lot through increasing the farmers' profits. This creates some tension in writings on the labour force, and Gilpin deliberately terrified his readers by writing that an idle peasant was more picturesque than an industrious mechanic, to strike home

the point about the picturesque being an *objective* aesthetic, one which permitted judgement to be made irrespective of what was being judged. He knew that people preferred to see their poor clean and industrious. Indeed, the closest visualization we have to the ideal described by agricultural writers, like Young and Thomas Ruggles, are the landscapes of George Stubbs (*Plate 84-6*).

These are superb works of art. In the same way as in his portraits of horses with jockeys or stable lads, there is a dispassionate objectivity which gives the impression that Stubbs has portrayed actual labourers. They line up across landscapes of wood and enclosures which he rolls into his distances and which are sufficiently topographically indistinct, perhaps, to satisfy the demands of any customer for scenes of rural England. Stubbs was not doing these works for patrons, but offering them for sale. He painted with great delicacy, and

85
GEORGE STUBBS:
Haymakers. 1794.
Enamel on a ceramic
plaque. Port
Sunlight, Lady
Lever Art Gallery

86
GEORGE STUBBS:
Reapers. 1794.
Enamel. New Haven,
Yale Center for
British Art, Paul
Mellon Collection

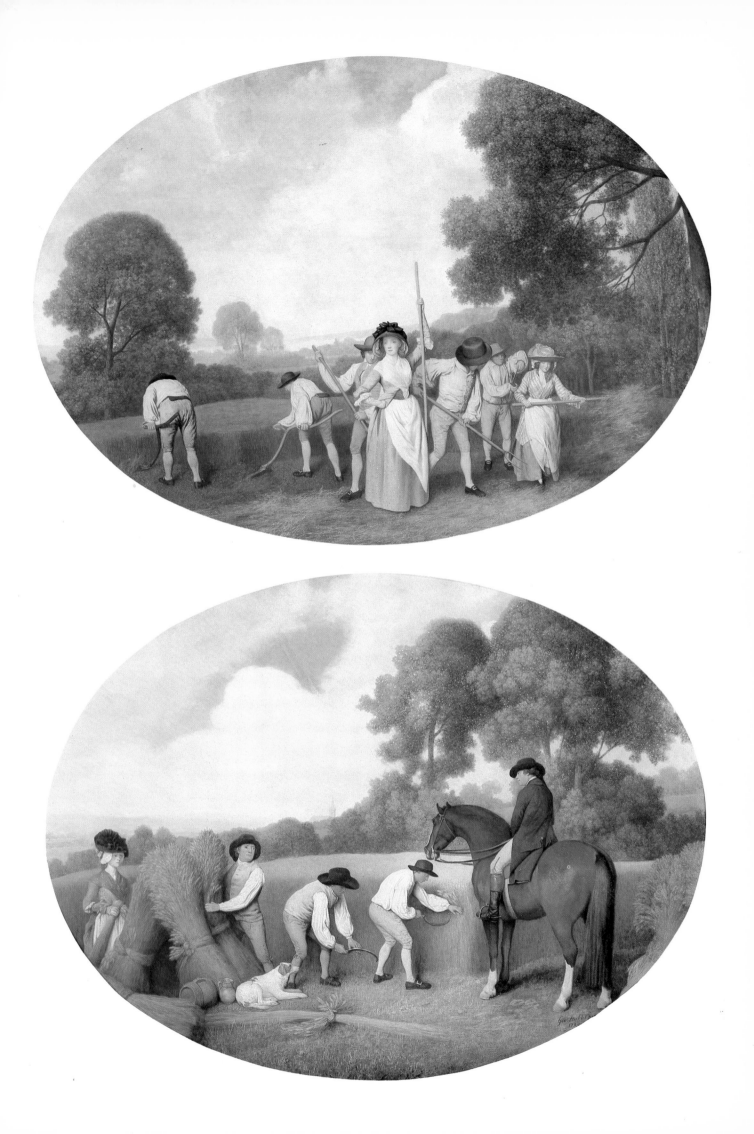

in these instances used enamel on pottery ovals rather than oil on canvas (as he did in other farming scenes) because he wanted technical perfection. He succeeded; the colours have preserved all their crispness, and the landscapes remain startlingly clear. But of course the thing one notices is not the fine management of the blue-blond tonality of the haymaking scenes, or the harsher but justly managed view across the ripe corn, but the way that the work force has been stretched out in a frieze across the picture plane to show that this is not only their environment, but that they are acting out for our benefit the work they perform there. Contemplating these pictures one gets an idea of harvesting or haymaking being explained through the various steps involved, an idea almost of their being a species of military drill.

Twentieth-century historians have been disturbed by one thing in these pictures. The labourers seem too clean, too kempt, to be doing the work they are shown doing. Harvesting is a dusty and dirty job. I suspect that an explanation for this may be found if we return to these works after looking at a couple of Stubbs's other paintings.

The early *Duke of Richmond's Racehorses Exercising at Goodwood* (*Plate 87*) has a certain charm in the triplicated horse and jockey galloping away across the Sussex Downs, surveyed by the Duke and his entourage. The landscape, which stretches away to the Channel coast, has been done with care, and we see Stubbs struggling between his desire to realize in paint and his capacity to do so. The composition is a clear descendant of the Prospect. The patron, the Duke, is shown surveying his land and his possessions; although in accordance with taste all is arranged in a naturalistic landscape, it remains, traditionally, a pictorial account of the Duke's domains and the uses to which they are put: Stubbs paints what the patron wishes people to see.

Of course the artist made a good living

portraying notable horses for their owners. In *Pumpkin with a Stable Lad* (*Plate 88*) of 1774, horse and boy are ranged across the foreground of a landscape of wood and lake. Both are neat and in good condition. The painting is a record of ownership with an implied reference to the laudable qualities of the owner, for this is not someone who supports scrawny nags and starving stable lads, but rather the opposite. They are, horse and boy, as neat as the reapers or haymakers.

Stubbs did not have to change the format when he turned to agriculture, he still arranged his subject across the foreground of an appropriate landscape. The difference is that the farming scenes were not done for a patron, but rather to appeal to the public: they were not commissioned (to take the analogy to its extreme) by the labourers' owners.

In the *Reapers* a mounted farmer stops to chat with a girl and her companion. Clifford Brigden noticed that in the version of the *Haymakers* without the wagon there was no mounted farmer, but all the same a girl leans coquettishly on her rake and stares straight out of the painting. What she stares at is us; Stubbs having employed a time-honoured means of involving the spectators with the painting. Accordingly we are allowed to play the role of farmer, and take an interested concern in what we are shown. We have to approve of the georgic peace and plenty Stubbs shows, and I would suggest that his labourers are so clean and unbothered by their work because they represent the ideal which the farming interest liked to believe existed on well-run farms. The converse, labourers in rags, idling around and swilling beer, could hardly rate approval (except Gilpin's) and while the farmer takes the credit for the exemplary specimens Stubbs portrays, they themselves take the blame if they go astray, for it is by putting themselves under the hands of a kind master that they can achieve this

87
GEORGE STUBBS: *The Duke of Richmond's Racehorses Exercising at Goodwood.* 1760-1. Oil on canvas. Goodwood House, Sussex

88
GEORGE STUBBS: *Pumpkin with a Stable Lad.* 1774. Oil on panel. Virginia, Upperville, Paul Mellon Collection

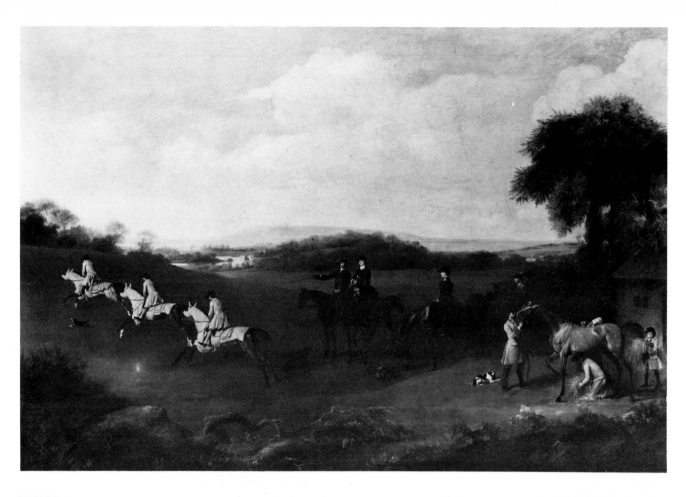

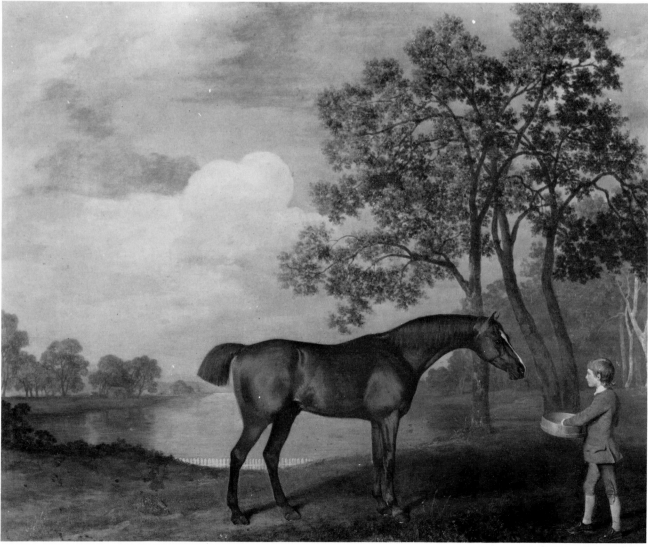

relatively desirable state. Or so Stubbs
would have us believe, and he is backed
up in this by numbers of agricultural
writers.

The traditional notion of the British
landscape asserted by these paintings in
some respects ran counter to the pictur-
esqueness or sublimity which had become
so fashionable. And in the relative boom
in agricultural landscape which dates
from the 1790s it can be said that history
played its part. There is ample evidence
that the French Revolution and
Napoleonic Wars helped invest such
landscapes with an increased poignancy.
They had a reassuring aspect in showing
the Arcadia that is Britain, defining the
value of what there was, and denying the
need for change. They showed what
stood to be lost with the war, and helped
boost the confidence of those with an
interest in these things — the farmers,
the landowners, or the patrons of art.

It is an interesting statistic that the
incidence of agricultural landscape and
rural genre in Royal Academy exhi-
bitions rose steeply after around 1790.
During the 1780s they never averaged
more than 1.5% of all exhibits, but in
1792 had risen to 4.23%, surely a re-
sponse to the downturn taken by events
in France. In 1805 rustic scenes com-
prised 1.59% of all exhibits, and in 1806
3.51%: which must show some reaction
to the glorious victory at Trafalgar. John
Barrell has noticed a similar rise in the
output of books on country life during
the Second World War. When you have
a chance of losing something, you tend to
ruminate upon the virtues of what you
already have. Indeed that early revival of
agricultural landscape in the 1770s may
have been partly in response to the war
with America.

The idea of popular revolution was
viewed with terror. In the 1790s there
was a flood of pamphlets urging the poor,
that vast, generally illiterate majority, to
realize that under the British Con-
stitution their life was far better than

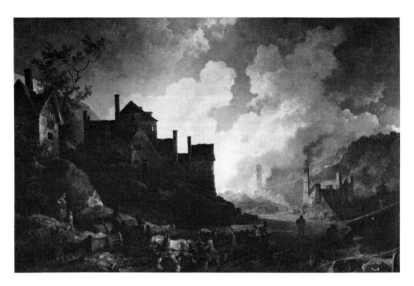

anything they might achieve by deposing
the ruling class. Agricultural landscape
pictured this idealized world, and other
factors lent it extra weight. The blockade
of Britain encouraged adventurous agri-
culture, the use of machinery, large-scale
enclosure, in the hope of becoming self-
sufficient in corn. Shortages inflated
prices, but there was work for all and it
was well paid, although the swift move to
a capitalist system of farming eventually
destroyed the old paternalist social order
in the countryside. To an uncritical eye
the British countryside would have
shown much to admire, and the artists
would have joined with this admiration.
Save for Blake, painters identified their
interests with those of the bourgeoisie
and aristocracy. And the war made
Continental travel very difficult, provid-
ing therefore further incentive to study
what lay to hand.

De Louterbourg and Paul Sandby
Munn even went so far as to glorify the
blazing industrial landscape (*Plates 89
and 90*), but most painters stuck to the
countryside. John Gage's *Decade of
English Naturalism* exhibition in 1969
showed the range and quality of the work
done before the motif. Wilson's teaching
had been transmitted by pupils like
Farington and Thomas Jones (*Plate 53*),

89
PHILIP JAMES DE
LOUTHERBOURG:
*Coalbrookdale by
Night*. 1801. Oil on
canvas. London,
Science Museum

90
PAUL SANDBY MUNN:
Bedlam Furnace.
Detail. 1803.
Watercolour. London,
Collection of Judy
Egerton

91
JOSEPH MALLORD
WILLIAM TURNER:
*Ploughing up Turnips
near Slough.* 1809. Oil
on canvas. London,
Tate Gallery

and oil sketching became a common practice (*Plates 92, 99 and 100*). With certain painters it relates directly to studio work.

Turner had toured the Continent extensively in 1802, but with the resumption of hostilities he had once more to stay at home. A Londoner, he did this almost literally by basing himself at Isleworth in 1804 and 1805, and beginning to make oil sketches along the Thames and its tributary the Wey. *The Thames near Walton Bridges (Plate 92)* is thought to be of around 1807. Reasonably large, technically it resembles the work Constable did along the Suffolk Stour after 1808. Turner worked at speed and gave a summary indication of houses or trees, but he was also wonderfully clever in creating a balanced composition, and, with a very limited palette, varied effects of texture.

This sketch is just one of many, and they are the ground work for the series of large and finished georgic Thames landscapes which he painted from the mid-1800s. One of these is *Ploughing up Turnips near Slough (Plate 91)* of 1809. Turner's 'near Slough' is a joking reference to the landscape at Windsor. The painting is actually a descendant of the Prospect, with 'Farmer George's' country seat placed behind (therefore visually approximating to the term of speech, it 'lies behind') a foreground of agricultural profusion and plenty. Cause and effect are neatly linked. Turner also used a predominantly golden colouring (perhaps to call up ideas of a Golden Age) to enhance the georgic completeness of it all.

Constable, who is famed for his oil sketches, also used these as the basis for finished pictures, and painted *Wivenhoe*

92
JOSEPH MALLORD
WILLIAM TURNER: *The
Thames near Walton
Bridges. c.* 1807. Oil
on panel. London,
Tate Gallery

93 JOHN CONSTABLE: *Wivenhoe Park*. 1816. Oil on canvas. Washington, National Gallery of Art

94 JOHN CONSTABLE: *Landscape, Ploughing Scene in Suffolk*, Replica of a painting of 1814. Oil on canvas. New Haven, Yale Center for British Art, Paul Mellon Collection

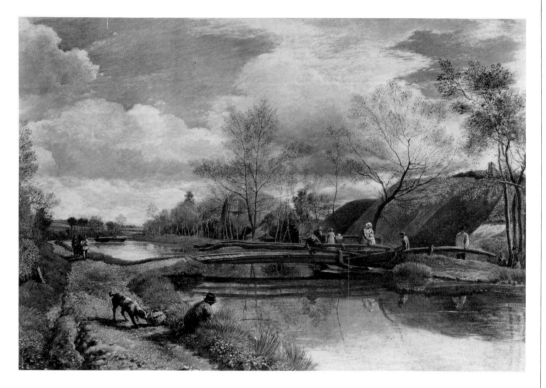

95
JOHN LINNELL: *Canal
at Newbury*. 1815. Oil
on canvas on wood.
Cambridge,
Fitzwilliam Museum

Park (*Plate 93*) wholly, and *Flatford Mill*
(*Plate 96*) probably partly, on the motif,
eliminating the need for oil sketches.
Constable's *Landscape, Ploughing Scene
in Suffolk* (*Plate 94*) replicates an 1814
composition and uses a ploughman to
qualify the Stour Valley landscape, by
making it the site of georgic incident to
show that it embodies in microcosm all
the rustic virtues one generally thinks of
in national terms. *Wivenhoe Park* is a
domestic variant of Turner's *Ploughing
up Turnips*. The mansion surveying the
park is not only formally beautiful, but
also useful in that its lawns feed cattle
and its lake provides fish. The painting is
brilliantly precise in touch and has an
uncanny equivalence to the look of
nature on a sunny summer's day. *Flat-
ford Mill* is also naturalistic and informa-
tive as to the actual workings of the land-
scape, showing what barges do, or how
the land is farmed. These details tell
within the whole and therefore again
qualify the landscape, rather than forc-

ing us to consider them on their own
terms, as Stubbs did with his friezes of
labourers.

John Linnell's *Canal at Newbury*
(*Plate 95*) is close in date to *Flatford
Mill*. Independent of one another, then,
two artists, both of whom liked to study
nature through oil sketches (Linnell pro-
duced some fine ones), turned to a very
similar kind of working landscape. And
they treated it in a style aimed at reporting
as accurately as possible the look of such a
landscape. While it cannot be called a
movement, it does seem that during the
war period and the years immediately
afterwards artists following similar pro-
cedures came up with comparable results.

Turner, Constable, and Linnell were
by no means isolated. British landscape
painting of this period achieves rare dis-
tinction. In 1806, Delamotte, composing
in greens and greys had sketched the
Thames landscape with total assurance
(*Plate 99*), and instinctively and nat-
urally made it georgic by adding a shep-

96
JOHN CONSTABLE:
Flatford Mill. 1816-17.
Oil on canvas. London,
Tate Gallery

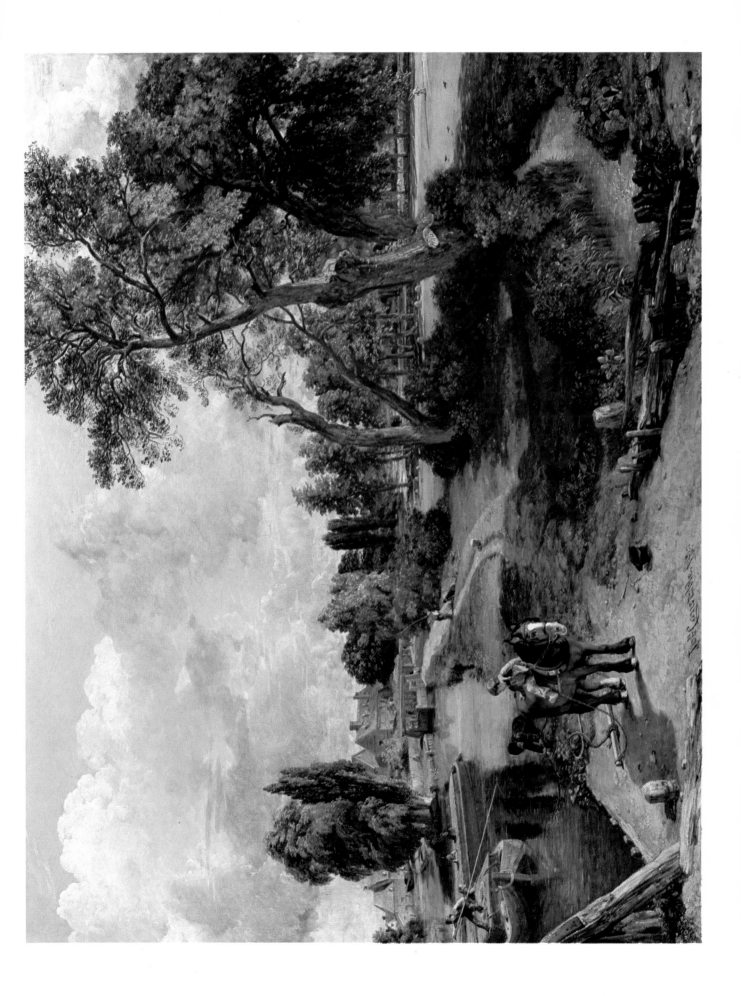

herd and a harvest scene. Other painters
could raise their performance. James
Ward was a specialist in boars and pigs,
and extensive sub-Rubensian land-
scapes; but in *Gordale Scar* (*Plate 97*) of
1808 he created one of the largest and
most impressive landscapes of this
period, in the same year as J.J. Chalon
painted his superb landscape with cow-
herds (*Plate 98*). While the connoisseur
will appreciate this for its debt to Cuyp,
Chalon took his example only to assist
him in portraying two figures and their
cattle sitting in the shady foreground of a
sweeping and sunlit landscape. He paint-
ed with that precision which with other
artists has stemmed from the direct
study of nature, to illustrate what is as
much a record of contemporary agricul-
ture as for instance Constable's
Ploughing Scene (*Plate 94*).

As late as the 1820s David Cox was
painting sketches of marvellous fluency

97
JAMES WARD: *Gordale
Scar, Yorkshire*. 1808.
Oil on canvas.
London, Tate Gallery

98
JOHN JAMES CHALON:
*Landscape with Cattle
and Cowherds*. 1808.
Oil on canvas. By kind
permission of His
Grace the Duke of
Westminster

99
WILLIAM DELAMOTTE:
*The Thames Valley
between Marlow and
Bisham*. 1806. Oil on
board. Private
Collection

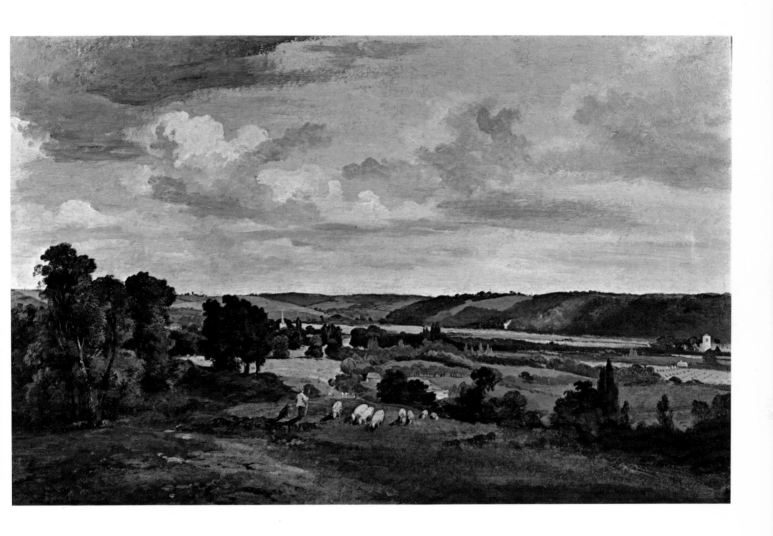

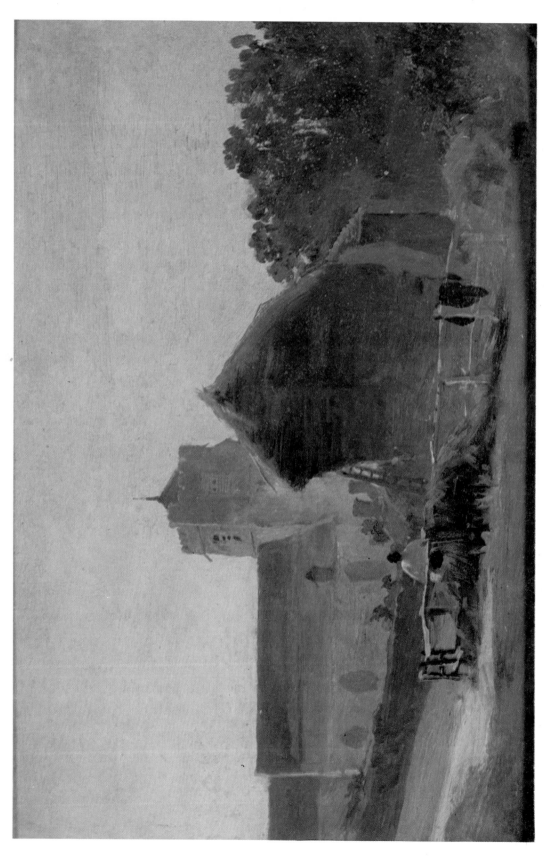

100 DAVID COX: *All Saints' Church, Hastings.* 1812. Oil on canvas. Birmingham City Museums and Art Gallery

101 ROBERT HILLS: *Sheltering from the Snow.* 1820. Watercolour. London. Private Collection

102
FRANCIS DANBY: *The
Avon at Clifton.*
c. 1822. Oil on canvas.
Bristol, City Art
Gallery

(*Plate 100*) like this one, which focuses on a straw stack, Danby did some excellent work around Bristol (*Plate 102*), and Robert Hills produced very fine watercolours of rustic subjects (*Plate 101*). Here he has actually achieved something like the effect of looking out in real falling snow, and portrayed a subject not that far from the firesides with which medieval artists would sometimes illustrate December in calendars.

While this intense wartime study of the domestic scene was not a movement organized by artists of common aims, it is feasible to isolate works like these and observe how far they reveal similar concerns on the part of their creators. In their different ways Turner and Chalon did conformable paintings of the British landscape at the same period. Likewise, for a moment Delamotte saw the Thames Valley in much the same way as

Constable was to see the Suffolk Stour. At the least we can say that at this period artists responded to domestic landscape in a similar way, by interpreting it georgically, and this might have been in response to the need for reassurance during a time of national crisis.

This celebration of the present is also a real, if idiosyncratic, strand in the paintings of the Norwich School. Cotman for instance turned to agricultural scenes, but with his particular genius was able to present a very ordinary marl pit (*Plate 103*) as practically an abstracted design in browns and blues, while his ploughed field (*Plate 105*) is a particularly desolate instance of a theme which had become popular with various artists. Crome's *Mousehold Heath* (*Plate 106*) is likewise one of these agricultural scenes, although more sophisticated than it looks. While it is a pastoral celebration of the

103
JOHN SELL COTMAN:
The Marl Pit. c. 1809.
Watercolour. Norwich
Castle Museum

Norfolk landscape, it is also a recasting of Gainsborough in the modern idiom (*Plate 104*) and the redeployment of the motif confirms its timeless value and thus exalts the Britain which the French would destroy. James Stark, another Norwich painter, followed more conventionally georgic lines in his scenes with sheep (*Plates 107 and 108*).

The final examples in this catalogue of wartime georgic landscape painting are two harvest scenes of 1815 (*Plate 109, 110 and 111*). Like the other pictures they are naturalistic in style, and affect to record actual events. De Wint's painting is a limpid and beautiful vision of the Lincolnshire open fields, gleaners sauntering through the stubble. Lewis on the other hand painted his view in Herefordshire more tightly and more dryly, but still gave us a clear account of how things were done. The theme of harvest, the

104
WELLS AND LAPORTE
(after Thomas
Gainsborough):
Shepherd and Sheep.
Aquatint, published
1 January 1802.
London, Victoria and
Albert Museum

105
JOHN SELL COTMAN:
The Ploughed Field.
c. 1812. Watercolour.
Leeds, City Art
Galleries

106
JOHN CROME:
Mousehold Heath.
c. 1812–13. Oil on
canvas. London,
Victoria and Albert
Museum

107
JAMES STARK:
Sheep Washing.
c. 1822–30. Oil on
panel. Norwich Castle
Museum

08
JAMES STARK: *Penning
the Flock. c.* 1818. Oil
on panel. Norwich
Castle Museum

idea of efforts rewarded, may well con-
nect with that first defeat of Napoleon in
1814.

The agricultural landscapes at which
we have been looking are the last great
flowering of the genre in British art.
Artists turned to the native scene and
studied it for its merits. Under cir-
cumstances of war a georgic iconography
was natural and invested landscapes with
profound significance; a non-romantic
art flourished briefly during a period of
romanticism because historical cir-
cumstances demanded that one respond
to and interpret reality. However, artists
were not able to maintain their painting
at quite this pitch.

As early as 1813 Turner, in his last
agricultural scene, *Frosty Morning* (*Plate
113*), had shown an expansive and bril-
liantly realized scene of a flat and frozen
landscape. There was no hint of topo-
graphy, no georgic interpretation of the
Thames. By 1815 with *Crossing the
Brook* (*Plate 114*), a view down to the
Tamar estuary, he was making the point
picturesquely by referring to the ideal of

beauty realized by Claude in his
Landscape with Hagar and the Angel;
form was significant, but there was no
content, which is a strong turn from the
idea of British landscape he had deve-
loped along the Thames. Constable, too,
abandoned the georgic, and moved
through a period of expressionism, until

109
GEORGE ROBERT LEWIS:
*Hereford from
Haywood Lodge.* 1815.
Oil on canvas.
London, Tate Gallery

110
PETER DE WINT: *The
Cornfield.* 1815. Oil on
canvas. London,
Victoria and Albert
Museum

111
Detail of Plate 109,
*Hereford from
Haywood Lodge*

112
JOHN CONSTABLE:
Dedham Vale. 1828.
Oil on canvas.
Edinburgh, National
Gallery of Scotland

he subsided into the picturesque (*Plate 112*). By the same token, our thinking of Crome as the manufacturer of native landscapes perceived as Hobbemas (*Plate 115*) rather than as a painter of documentary pastoral (*Plate 106*) may also show that the georgic was a fragile way of seeing. Bearing in mind Stubbs's labourers, the rustics Barker etched in 1813 (*Plate 116*), have a disquieting hostility in their countenances, although they are probably part of that general georgic response to the times.

This hostility would point to the possibility of the poor denying the interpretation of their lives foisted on them by farmers and artists. And it does appear that the reason painters abandoned the

113
JOSEPH MALLORD
WILLIAM TURNER:
Frosty Morning. 1813.
Oil on canvas.
London, Tate Gallery

114
JOSEPH MALLORD
WILLIAM TURNER:
Crossing the Brook.
1815. Oil on canvas.
London, Tate Gallery

115
JOHN BERNAY CROME:
*Near Bury St
Edmunds.* 1832. Oil on
canvas. Norwich,
Castle Museum

georgic was because reality could not accept it. Professors Hobsbawm and Rudé have described a change in rural society from one which could be interpreted georgically to one which could not. The post-war agricultural depression meant penury for the poor, and social concord was shown as an illusion by disturbances in East Anglia in 1816 and 1822: disturbances, however, differing from the traditional bread-riots, for these were labourers rioting for work. The availability of machinery and a reduction in corn prices encouraged farmers to lay men off rather than pay them for doing nothing. The old order was under pressure as the 1820s saw increasing agitation for Parliamentary Reform, and in 1830-31 the change in rural Britain was confirmed by the 'Swing' riots. The 'Merrie England' of georgic landscape was hardly credible: artists had to seek alternative forms of landscape, and were forced into romanticism.

Samuel Palmer made celebrated drawings and paintings in the Kent village of Shoreham, where he was from the mid-1820s (*Plates 117, 118 and 120*), translating the lessons of Blake to a contemporary pastoral. Their subjects are the kinds of thing we have been considering and give a cumulative impression of repose and fruition, of a timeless goodness at that one spot. One should point out, however, that compared to the painting of the 1810s these images look peculiar: people, hills, trees do not look like that. And though Palmer's creation of an alternative reality can be conventionally traced to the lessons of Blake it could be that he had to adopt this manner to depict what he wanted to see in Shoreham, pastoral bliss in rural retirement. Kent was very badly hit by the rick-burning and machine-breaking that went with Swing. It must have been noticeable for some years previously that all was not well in the countryside. Yet Palmer maintained his formal vocabulary into the years of the Disturbances, a vocabulary he now had

THOMAS BARKER:
Rustic Figure after Nature. 1813. Lithograph. London, Courtauld Institute, Witt Library

to create to deal with a traditional iconography.

After Palmer agricultural landscape is hardly distinguished. Collins showed one way of confronting the poor in *Rustic Civility (Plate 119)* of 1833, where the mawkish sentimentality is compounded by the lad pulling his forelock. At least Stubbs's poor had not sunk to such subservience. An attempt to do agricultural landscape had little chance of success. Only Turner tells the truth in *Rain, Steam, and Speed (Plate 121)* of 1844. This is set in the same terrain he had painted so beautifully in the 1800s, and which he had seen as embodying through both landscape and its inhabitants the georgic virtues of Britain. Now it is blurred into indistinctness and the chief object is the train, the sign of the new age, which almost obscures totally a small working plough, the remnant of the old. The Victorian era puts new demands on painters, and some indication of how far things had changed may be had from knowing that while Turner was painting his last works, the Pre-Raphaelites were doing the first of theirs.

117
SAMUEL PALMER:
Cornfield by Moonlight. 1830. Watercolour and gouache. Collection of Lord Clark

118
SAMUEL PALMER: *The Valley with a Bright Cloud*. 1825. Pen and brush, and sepia. Oxford, Ashmolean Museum

119
WILLIAM COLLINS: *Rustic Civility*. 1833. Oil on canvas. London, Victoria and Albert Museum

120
SAMUEL PALMER: *Hilly Scene. c.* 1826-8. Tempera, watercolour and pen. London, Tate Gallery

121 JOSEPH MALLORD WILLIAM TURNER: *Rain, Steam, and Speed*. 1844. Oil on canvas. London, Tate Gallery

5 The Victorians and Beyond

If we consider art history to be the history of styles, or artistic preoccupations, then the period after 1837 is fascinating. However, in landscape little new was invented, and if we follow what we have been taught is a proper approach and take art history to be about the heroic struggles of an embattled avant garde, there is little room for painting of the kind we have been discussing. Further, if 'important' painting is that which in the nineteenth century notices French art, and in the twentieth moves towards abstraction, landscape has little part to play. In 1981 it is impossible to reconcile the cultural gulf between the pleasing and thoroughly traditional landscape paintings exhibited each year at the Royal Academy and the conceptual landscape experimentation of a Richard Long.

The wealthy Victorians had little similarity with any class which had previously interested itself in art patronage. Their wealth came from towns. And chiefly they lived in towns, although architects made a good living designing vast country piles to give them and their families a reassuring, if fake, social repute. Although their recent ancestors may have been country dwellers, this past had been left so far behind that we find an enormous cultural divide between the late Regency and early Victorian periods.

En masse this new bourgeoisie was not appealing. The deplorable conditions under which those whom they exploited in getting rich lived are notorious; the received image of the working-class quarters of the Victorian city makes the blood run cold. And the fact that art was patronized for the conventional reason, to show off the culture and civilization of the patron, can raise a hollow laugh. It was not that Georgian patrons had been any less brutal, but that there were fewer of them and their influence extended to fewer people.

The Victorians were enraptured by anecdotal painting, art which took subjects easily recognized in daily life and used them to tell some simple and easily understood story. Augustus Leopold Egg's *Past and Present*, 1858, (Tate Gallery) dealt in three stages with a story of domestic decline and disaster: a wife having cuckolded her husband ends up destitute, gazing through the arches of the Adelphi at the moon and the Thames. The moral was as clear as Egg's style, and while today the treatment may hint of hypocrisy, *The Art Journal* found it 'a subject too poignant for a series of paintings'. To feel its force one needed to be a contemporary of Egg's. The cold facts of life were gloriously celebrated. Frith's illustrative *Derby Day*, 1856-7, (Tate Gallery) was actually fenced off from the marvelling mobs. If paintings meant anything it was not conveyed subtly. Lady Butler's *Scotland for ever!*, 1881, (Leeds City Art Gallery) is a stirring illustration of the charge of the Scots Greys at Waterloo, meant to inspire the breast with patriotic fervour, unmindful of the necessity not to ques-

tion the myth if the force of its message was to be preserved.

I suggested that the guiding characteristic of romanticism was the creation of theories to explain the world, to fill the void created by the discrediting both of Newtonian rationalism, and, to a lesser extent, of Christianity. The strength georgic subjects had shown during the Napoleonic Wars depended on unique circumstances. The void had not been filled from the 1820s onwards, and this taste for the anecdotal, this craving to find a meaning in everyday life, may have been in part an attempt to supply the need. The counterpart was escapism. In medieval scenes, which had an abiding popularity, the artist could become immersed in portraying a life which seemed preferable to the one being lived. And there was another aspect of this shown up in landscape. Collins's *Rustic Civility* (*Plate 119*) with its acquiescent and forelock-tugging child stands at the beginning of a series of sweet and completely unreal cottage scenes glutinously climaxed in the work of Myles Birket Foster.

The Victorian era broke drastically with the recent past. It was now possible to travel far greater distances and far more easily than ever before, not only through Britain. The difference is between the rigours experienced by Ibbetson in Wales, and the rather blasé treatment of a tourist-infested beach painted by Frith in *Ramsgate Sands* (1854). Photography was developed, and this had a large effect on the history of painting, not least because a photograph, in the form of a picture postcard, could now serve the same function as a topographical watercolour. And it seems no accident that the clarity and exactness of Pre-Raphaelite art coincides with the rise of the photograph. While photography, assembling mountains of naked people in historical tableaux, attempted to rival painting, painting itself tried to outdo photography. Leader's *February*

Fill Dyke (*Plate 138*) has a photographic clarity. It also has colour and sentiment: painting triumphs. Photography usurped something of the artist's previous concern with the portrayal of nature, and must have promoted the state of affairs towards the end of the nineteenth century when Whistler was denying that painting had any function other than the creation of objects 'independent of all clap-trap' and 'should stand alone and appeal to the artistic sense of eye or ear without confounding this with emotions entirely foreign to it' (*The Red Rag*, 1878). This single-minded and élitist aestheticism carries us far beyond any idea of painting having an iconography.

As I said, the 'meaning' Victorians found in their paintings was generally of an anecdotal sort, related to typical incidents of modern life. And the location of these incidents was often the town. As cities grew they fascinated painters and writers, creating new classes of person and new ways of living. The relative stasis of the countryside, even though such mechanical aids as steam ploughs were coming in, must have seemed tame, even uninteresting. Ease of travel, furthermore, had made the country accessible to all and it could be so taken for granted that it was hardly noticed. And despite this confidence, because things had developed at such speed, one does get a sense of this being a society which had acquired its riches so fast that it needed to be taught how to use them. Having acquired their culture, they needed aesthetic guidance.

Art criticism had been a relatively minor kind of writing. After the accession of Victoria it became a growth industry. Newspaper writers explained art to middle-class readers, and a process of mutual reassurance confirmed to the satisfaction of both that this modern age was easily the equal of any other high point of civilization. The greatest art critic was John Ruskin, and in singling him out we can inspect some of the

122
DAVID COX: *Haymaking near Conway*. 1852-3. Oil on canvas. Manchester City Art Galleries

123
THOMAS CRESWICK: *A Summer's Afternoon*. 1844. Oil on canvas. London, Victoria and Albert Museum

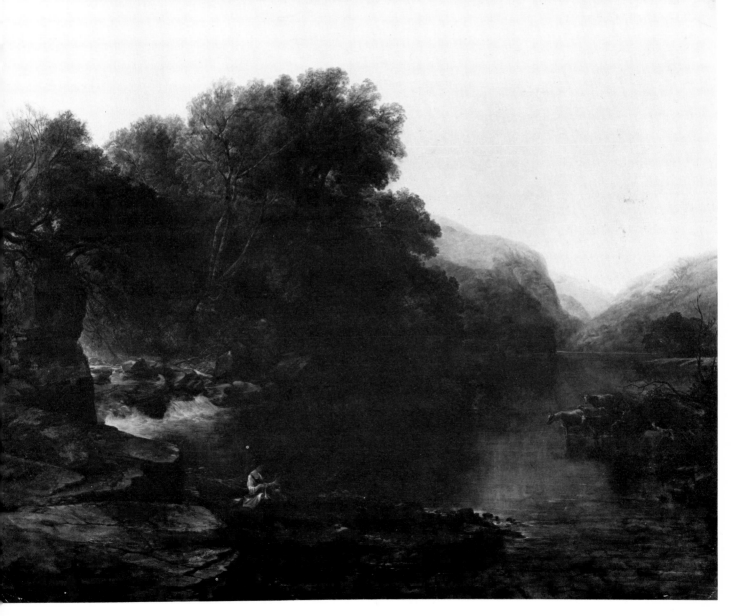

peculiarities of the age in greater detail.

Ruskin's writing was forcefully didactic. He told his readers what was good, and they were only too grateful to learn from him. Both accepted that the true comprehension of art was outside the grasp of the mass and that it needed an intermediary, a priest, to transmit the mysteries to the congregation. Ruskin is famed for championing Turner in *Modern Painters* I (1843), and his view that Turner was the greatest landscapist ever because he had penetrated and then displayed nature's truths more than anyone before him had done was of no small consequence to the development of the Pre-Raphaelites. Ruskin's greatness must be acknowledged: yet he was incapable of appreciating some great art. He could see little virtue in Claude because Turner had done it better. He had lost that sense of history, inculcated by Reynolds in the *Discourses,* which saw painting in continuing evolution, and which meant that although Turner could build on Claude's example the latter was yet one of the very greatest of landscape painters.

Ruskin shows in himself how far out of sympathy with the previous age the Victorian era was. He found in Constable's landscapes only that the artist had perceived 'that the grass is wet, the meadows flat, and the boughs shady; that is to say, about as much, I suppose, as might be apprehended between them, by an intelligent faun and a skylark'. He was blind to Constable's virtues because he was unsympathetic to them. He still made pronouncements, formulated doctrine, and accepted public gratitude for it. He laid down a code of landscape procedure, yet, hailing from Dulwich in the London suburbs, could never have *known* landscape as completely as a Constable, Wilson, or Gainsborough. He was driven by a fanatical earnestness and had a profound effect on the directions landscape painting took.

The Pre-Raphaelites were so impressed by Ruskin's defence of Turner, and so enraptured by the post-Wordworthian thesis that as God was revealed in nature, so by transcribing nature, which they took as meaning appearances, they would reveal God and their painting would automatically gain profundity and value, that they decided they needed only to study with intensity and transpose accurately the sights of the fields. Somehow the theory was flawed: photographs could be seen to have rather less power to move the emotions than paintings, yet they transcribed nature direct. John Brett painted his *Val d' Aosta* under Ruskin's direction; it has an almost photographic exactness, and yet Ruskin was dissatisfied: it lacked emotion. In a way it was an image without meaning, and it can seem that like most Victorian painting it struggles unsuccessfully to gain it.

This may be why anecdotal art was so popular. It could be understood and could arouse sentiment, and thus justify itself. It could also seem trivial. In the 1870s there was a reaction against recent art, and we can begin to see an avant garde, elegantly guided by Whistler, detach itself from the academic mainstream. In 1893 George Moore defined Whistler's achievement in these terms:

More than any other man, Mr. Whistler has helped to purge the art of the vice of subject and the belief that the mission of the artist is to copy nature.

Thinking painters rejected the trivial and developed an art of formal value. This leaves little scope for the kind of approach I have been following because subject in landscape ceased to have as much importance or worth as it had had. By the early twentieth century that fine artist Harold Gilman was painting Mrs Mounter, the market at Leeds, or what have you, with an identical commitment to structure and colour. By the 1910s Wyndham Lewis had celebrated the city

124
WILLIAM SHAYER: *A Shady Corner.* 1840. Oil on canvas. Private Collection

125
JOHN LINNELL: *Noonday Rest.* 1865. Oil on canvas. London, Tate Gallery

and mechanization, and had painted abstract pictures. Following Whistler's lead, avant-garde art had become an élitist activity.

Much Victorian painting repeats the themes developed in eighteenth- and early nineteenth-century landscape. Although many pictures are of extraordinary quality on their own terms, for example Millais's *Autumn Leaves* (*Plate 139*), they can no longer be considered, like, say, Wilson's *Pembroke Town and Castle*, as a king of cultural icon. Towards the close of the century, however, some painters, in particular Clausen, showed something of a return to the study of landscape and country life and produced an art with meaning, with an iconography of simple rustic virtue, taking up a time-honoured theme which in the 1890s and 1900s was gaining renewed popularity. Later in the chapter we shall consider this and what follows, but first I want to consider landscape before the Pre-Raphaelites.

By the late 1830s artists had all landscape motifs available for exploitation. While Bright (*Plate 67*) maintained the tradition of the Norwich School, and Cox (*Plate 122*) and De Wint continued producing lightweight and pleasing farming scenes, other pre-1860 landscapes (excepting some Pre-Raphaelite work) tended to be illustrative, resulting in a collection of works so anodyne in treatment that they make a depressing sight. Creswick's *A Summer's Afternoon* (*Plate 123*) is a banal pastoral equal to the works of the late Samuel Palmer or Linnell's georgic in his many harvesting scenes of the 1850s onwards (*Plate 124*). Although Linnell may have developed a personal georgic, a painting like *Noonday Rest* (*Plate 125*) of 1852 uses its exhausted figures as mere adjuncts to the landscape which register equally with the clouds or sheaves as things typical of a summer's day, what you might see in a glimpse as you passed by on the train. The labourers' exhaustion attracts

condescension rather than sympathy or even approval for having worked so hard. Indeed the reaction to Witherington's virtually contemporary *Harvesting* (*Plate 127*) is to wonder how a painter could hammer away at such a retardataire theme. The answer is probably to be found in the market-place. Artists, once they had found a selling line, tended to stay with it.

The georgic was losing relevance. By the same token it is hard to find any Victorian poetry before Hardy's where it had more than superficial meaning. If for instance we pair Mulready's *Haymaking: Burchell and Sophia* of 1846-7 (*Plate 126*) with Burchett's Isle of Wight landscape (*Plate 128*) of 1855 the contemporary role of these tradi-

126
WILLIAM MULREADY: *Haymaking: Burchell and Sophia.* 1846-7. Oil on canvas. Private Collection

127
WILLIAM FREDERICK WITHERINGTON: *Harvesting.* 1851. Oil on canvas. The Fine Art Society Ltd

128
RICHARD BURCHETT: *The Isle of Wight. c.* 1855. Oil on canvas. London, Victoria and Albert Museum

tional subjects is defined. The former illustrates a scene from Goldsmith's *Vicar of Wakefield,* and is therefore one of a genre including works like Leslie's pictures after Sterne which suggests a nostalgia for the simplicity of the eighteenth century. Mulready's subject is the clerical father's chariness of his daughter being courted. The hayfield had traditionally been the place for much boisterous intercourse between the sexes, but this iconography seems not to have been in Mulready's mind. He wanted us to be touched by the subject, and there is no sense of this being a painting where agriculture, phenomenally summary in description, has any importance. In this artist's case it is an interesting development, for he had been one of those early nineteenth-century oil sketchers, and his *The Mall, Kensington Gravel Pits,* 1811, (Victoria and Albert Museum) is not untypical of the naturalistic work which resulted from such study. By the 1840s he can be seen to have pursued another line altogether.

Burchett was equally insensitive to agricultural subjects. His cornfield is just part of a landscape where middle-class people take their leisure. The corn is no more or no less useful than the beaches which we can imagine to be in the distance of this brilliantly coloured painting, and which at this period were being portrayed by artists like Thomas Marshall and William Gale as bourgeois *loci amoeni.* Agricultural scenes could give pleasure, but so could landscapes in the Highlands, or abroad. The subject-matter was irrelevant save as a contrast to the town, which was probably due to the population itself now being predominantly urban. Townspeople did not need the georgic; if they wanted a picture which emphasized the virtues of hard work a street in Hampstead was its natural location; if this Victorian middle-class wanted morality, artists like Egg were only too ready to do pictures of contemporary urban scenes which hit

hard precisely because their incidents were so recognizable, and people could identify with them.

This aimlessness with regard to landscape comes over, too, in the works of the Pre-Raphaelite Brotherhood. This was formed by a group of young painters in reaction both to the gross materialism of modern life and to the low state they saw modern painting as having reached. However, they expressed their reaction stylistically, although there are works which show a corporate sympathy for the medieval, and which tie in with the post-Puginian stage the Gothic Revival had reached.

It is easy to admire the pictorial virtues of Pre-Raphaelite landscape, and yet the historian comes to feel that in dealing with more than a couple of paintings the text will become repetitive. Although not typical of his earlier work, as less particular attention is paid to itemizing objects and the distance is important, Millais's *The Blind Girl (Plate 129)* of 1856 typifies Pre-Raphaelitism at its best. The painting studies bright sunlight against black storm clouds with a double rainbow, conditions which enhance the way light defines reflecting surfaces. The background features buildings, and crows and cattle on a yellow meadow, and the subject is the sympathy aroused by our realizing that the girl herself cannot see this glorious display. Indeed the main subject of this work comes to seem a catalogue of the resources of modern painting. There is the typical Pre-Raphaelite colouristic brilliance created by working on a wet white ground and using the refined pigments which modern technology had made available, and Millais almost ostentatiously celebrates this increased chromatic capability. He is indifferent to the opportunity of embodying social sentiment through the figure; it is no matter that she is a beggar and earns her bread by playing the concertina. The realization of the landscape, the technique are

129
JOHN EVERETT MILLAIS: *The Blind Girl.* 1856. Oil on canvas. Birmingham City Museums and Art Gallery

130
WILLIAM HOLMAN
HUNT: *The Hireling
Shepherd*. 1851-2. Oil
on canvas. Manchester
City Art Galleries

stressed, but not the subject, and this is often the case in Pre-Raphaelite landscape, in particular in those done by Holman Hunt.

The Hireling Shepherd (*Plates 130 and 131*) is too obviously the result of earnest study in the open of different sections of the composition. One wonders whether Hunt might more successfully have transcribed the nymph from her studio pose, and if the mind is not a little too literal that has unshorn sheep and ripe corn together. The shepherd has an obvious sacred connection with the Good Shepherd, but it is made with little strength, and it is equally hard to guess that there is an intentional irony in Hunt's painting of sheep at loose on a cliff (*Plate 133*). Certainly it is brilliantly painted, and we can marvel at the precision and the patience which achieved this. But the context of worries about a Britain undefended from the possibility of invasion, hence the 'symbolic' sheep, is hardly self-explanatory, and an in-

stance of a necessarily personal iconography. The pattern of shepherds and sheep may have a long ancestry in landscape painting, but the way it is used is outside that tradition. This is earnest painting and tries so hard to please that it lacks bite. Hughes's *Home from Sea* (*Plate 132*) is again superb if you want a painting of a rural churchyard on a summer's day, but the element of the returned prodigal, the sailor boy home from sea to find his mother dead and buried, is trite. These paintings are truly Victorian in their very dearth of meaning.

When artists associated with the Brotherhood went out to study on the motif the results were both stunning and oddly unsatisfactory. What an earlier generation would have made into a sketch now appears highly finished; for instance, Inchbold's *Study in March* (*Plate 134*). This is fascinating in showing an uncomposed and apparently randomly selected corner of nature, and in

131
Detail of Plate 130,
The Hireling Shepherd

132 ARTHUR HUGHES: *Home from Sea*. 1856-63. Oil on panel. Oxford, Ashmolean Museum

having an obsessive tightness of focus. Yet we do not feel that this study does any more than a photograph might, and possibly the intention of the lack of composition and precision was to rival photography. From time to time Ford Madox Brown produced pure agricultural landscapes (another, *Carrying Corn*, Tate Gallery, is not reproduced here). In *The Hayfield* (*Plate 136*) of 1855 he captured the light of a midsummer's evening, with the moon and afterglow, and figures going about their haymaking, observed by the artist himself. There is a superb detail of loading the wain in the right background. Despite his traditional subject, Brown ignored stock iconographic features, and the image works in terms of individual achievement, a superb study of a landscape reacting to particular conditions of light. It has a whiff of timelessness but is hardly part of the artistic tradition of haymaking landscapes. At Walton in 1860 (*Plate 135*) he brings us back to the seaside and his colouring obtrudes. The greens and reds of the harvested field link to the blue of the Naze almost like panels of stained glass. There is a moon again, and a rainbow to dazzle both us and those figures in the foreground, who are evidently on holiday, for the girl has a spade.

The Pre-Raphaelites are only united as a group through style and a theory of how painting should be done. Hence they produced beautiful and enigmatic works like *Autumn Leaves* (*Plates 139*) together with others, like *The Hireling Shepherd* (*Plates 130 and 131*), of lumpish earnestness. The group is documented, it worked together and argued together, yet significantly we have no need to illustrate paintings by Dante Gabriel Rossetti, because although as good a Pre-Raphaelite as any he was unconcerned with landscape. Unlike the Hogarth School, which had common habits of thinking about subjects and a common philosophy as well as a common style, here all that is common to the group is an approach to painting. In historical terms we can judge it only on its success or failure in achieving its technical ends. Its subjects are much as those of much other contemporary art. Despite its obvious quality and occasional brilliance, Pre-Raphaelite painting is at its best (*Plate 136*) completely enigmatic, without subject, because it was historically impossible to escape the philosophical bankruptcy of midnineteenth century Britain. *The Hireling Shepherd* is contemporary with *The Monarch of the Glen* (*141*) and has an equal moral profundity.

The realist style the Pre-Raphaelites had introduced spread fairly widely and results late in the nineteenth century in a number of pleasing, inoffensive landscapes. Horatio McCulloch invested Loch Katrine (*Plate 137*) with all the interest of a still-life in 1866, and to an extent this was also true of one of the most famous of nineteenth-century landscapes, Benjamin Williams Leader's *February Fill Dyke* of 1881 (*Plate 138*). Its uncanny charm lies partly in managing to portray so dismal a subject so appealingly. The view is painted with intense clarity, the golden evening and horizontal strata of the clouds picked out finely to set off the silhouettes of the boughs, and the lonely figures trudging through the puddles. But again it evades any iconography. The title comes from a rhyme of medieval antiquity yet the image has no connection with the Labours of the Months which the rhyme has, and Leader anyway said that the title was erroneous, he had painted in November.

It is a kind of painting which was also done by others. The images are pleasing but do not repay prolonged study in the same way as, say, Turner's *Rain, Steam, and Speed* (*Plate 121*). Banks Davis's *Now Come Still Evening On* (*Plate 140*) or Farquharson's *The Sun had Closed the Winter Day* (*Plate 142*) both breathe a peace and tranquillity akin to the feeling conveyed by De La Mare's *Nod:*

134
JOHN WILLIAM INCHBOLD: *A Study in March.* 1855(?). Oil on canvas. Oxford, Ashmolean Museum

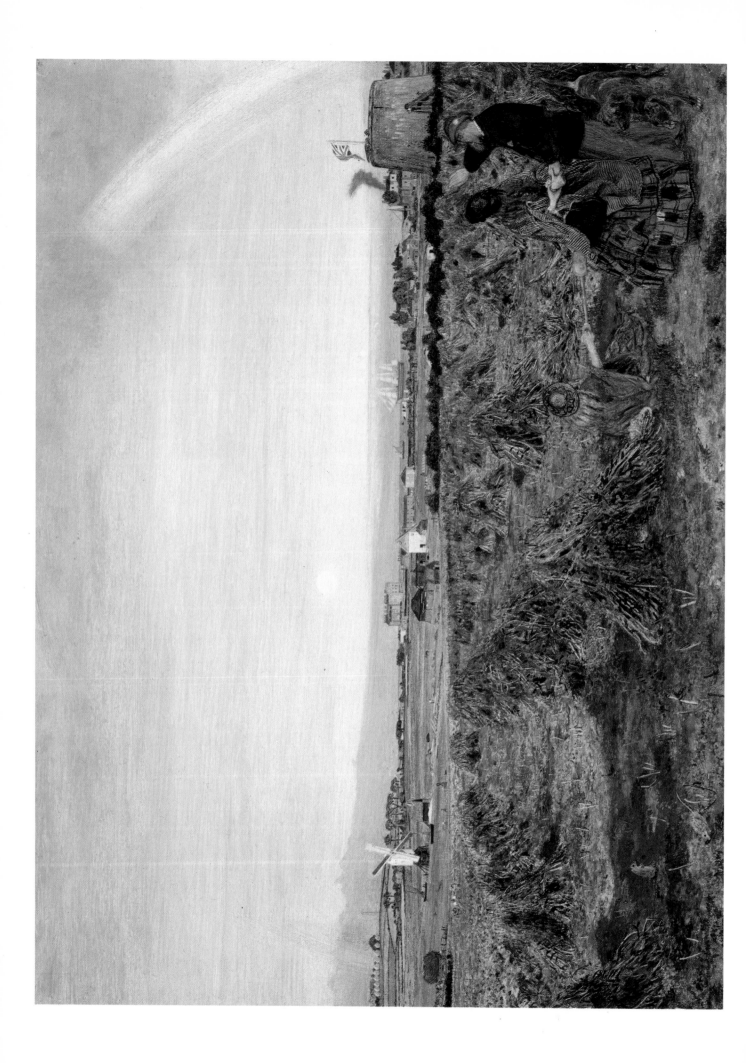

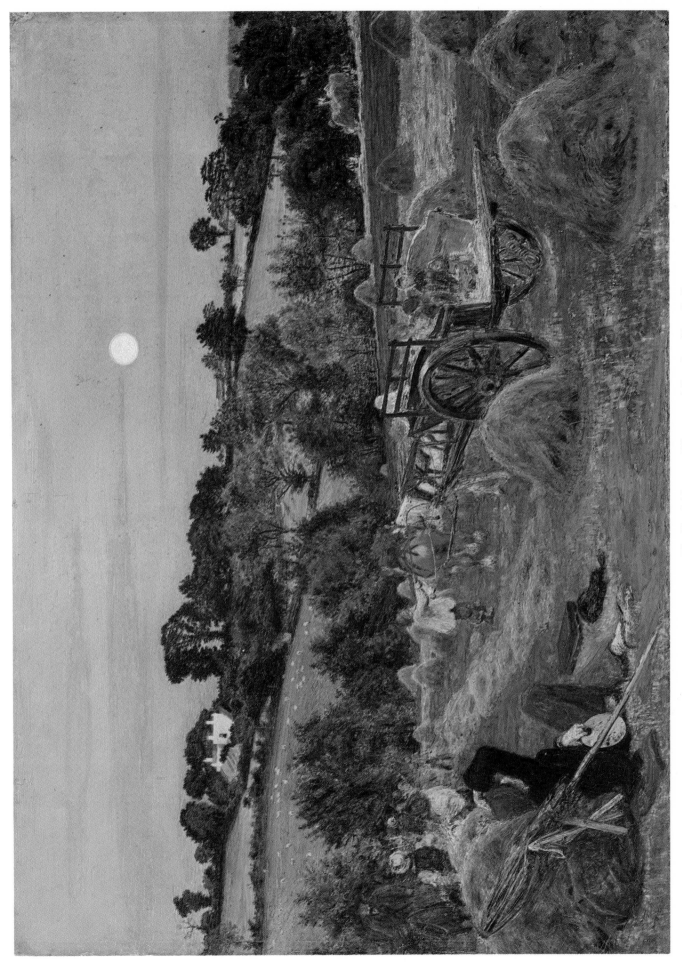

135 FORD MADOX BROWN: *Walton-on-the Naze*. 1860. Oil on canvas. Birmingham City Museums and Art Gallery

136 FORD MADOX BROWN: *The Hayfield*. 1855. Oil on panel. London, Tate Gallery

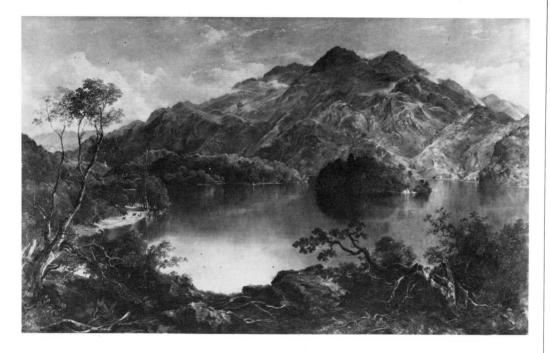

137
HORATIO MCCULLOCH:
Loch Katrine. 1866.
Oil on canvas. Perth
Museum and Art
Gallery

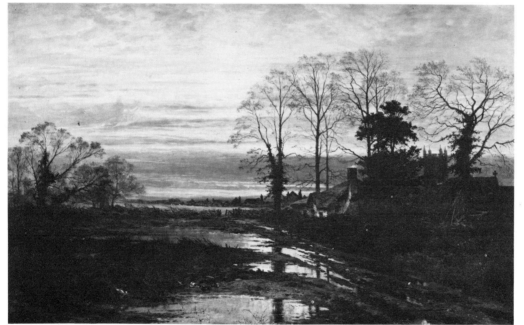

138
BENJAMIN WILLIAMS
LEADER: *February Fill
Dyke.* 1881. Oil on
canvas. Manchester
City Art Galleries

Softly along the road of evening,
In a twilight dim with rose,
Wrinkled with age, and drenched with dew,
Old Nod, the shepherd, goes.

The idea of the rustic as a part of land-
scape goes back to Wordsworth, and is a
comforting myth in its separation of poet-
ic or painted themes from any sort of
documentary reality: in 1874 the Suffolk
farmworkers had been locked out for
asking 14 shillings for a 54-hour week, and
when, if at work all week a man could

139
JOHN EVERETT MILLAIS:
Autumn leaves.
1855-6. Oil on canvas.
Manchester City Art
Galleries

earn just 7 shillings compared with 8 in 1813. These paintings are as anodyne as the earlier agricultural scenes. In their provision of harmless and escapist images they do little credit to the tradition with which they loosely connect, but then neither were they meant to. They were done to relieve the wall spaces of the mansions their purchasers were having built and functioned as cultural wallpaper. In terms of official art, the kind of thing produced for the Royal Academy, there was little development, and the real nature of much painting is revealed in the Introduction to the 1894 edition of *Royal Academy Pictures*.

The revival of commerce, which we are assured has taken place within the last few months, is too recent a movement to have made itself felt in the world of art. For art is a flower that blossoms in the sunshine of prosperity...

Painting, a commercial product, used safe subjects. So one could approve of pictures of snow-bound sheep, or labourers wading along a muddy track, because they were effectively meaningless. By the late nineteenth century the intel-

140
HENRY WILLIAM BANKS DAVIS: *Now Come Still Evening On.* 1887. Oil on canvas. Whereabouts unknown

141
EDWIN LANDSEER: *The Monarch of the Glen.* 1851. Oil on canvas. London, Messrs John Dewar and Sons Ltd

lectual pretensions of such subjects were being encapsulated in their titles. Calderon called his 1894 painting of horses hauling a timber cart *Toil*; it is the same outlook that calls a picture of a stag in the Highlands *The Monarch of the Glen*.

Nevertheless during this period other artists had produced work of some distinction. Fred Walker's *The Plough* (*Plate 144*) for instance is an intelligent piece of archaizing. It moves from a meaningless present to a meaningful past, and uses a medieval calendar prototype for the pattern of the ploughman, translating it into modernity via medium and technique. Henry Wallis deserves to be remembered for his *Stonebreaker* (*Plate 143*), a powerful contrast with Brett's insipid variant of the theme, and a painting to be compared with Courbet's celebrated *Stonebreakers*. The landscape is shown on a still evening, grey hills silhouetted and throwing a reflection in water, setting off the reddish foreground of stones and stonebreaker. He has died and is ungainly. He would also have been a pauper on out relief and the contrast with that reality and the beauty of the evening lends the canvas a genuine poignancy.

By the later nineteenth century matters become complicated. Some artists were reacting against the Royal Academy and its methods, and it has been opined that the establishment had by the 1860s reached a nadir from which it has hardly raised itself since. Certainly if one looks through the *Royal Academy Illustrated*, the reproductions of the most distinguished paintings at the annual exhibitions, for any year in the 1910s it is a startling experience. Many of the works reproduced could have been done at any time in the previous 35 or 40 years, and there is a strong feeling that, save for a few cases, Impressionism (which is largely concerned with landscape of course) need never have happened. Some painters knew what was going on

in France, now the artistic centre of Europe, and were seeking alternatives to the kinds of painting at which we have been looking. Chief amongst these is Whistler, and historically there is a new and significant development as the avant garde at this period, the late nineteenth century, detaches itself from the academic mainstream and starts becoming what it so markedly is today, an élitist activity of little social consequence. In the 1920s the *Daily Mirror* still considered reviews of paintings interesting to its readers; in the 1980s it needs the Arts Council to sponsor some 'outrageous' activity, like incorporating

142
JOSEPH FARQUHARSON:
The Sun had Closed the Winter Day. 1904.
Oil on canvas.
Manchester City Art Galleries

143
HENRY WALLIS: *The Stonebreaker*. 1857.
Oil on panel.
Birmingham City Museums and Art Gallery

horse dung into a piece at the Serpentine Gallery for 'art' to make the popular press. Historians prefer to study the avant garde and they like to see pictures which either respond to French painting, or become abstract, and a craving to see British art in the forefront of European developments in the twentieth century has led critics to invest the works of Ben Nicholson in particular with unwarranted importance and consequently to ignore much else of equal interest.

Although landscape painting persists it has little to do with developments in modern art. Sickert, one of the most advanced British painters at the end of the nineteenth century, hardly noticed it, and in detecting responses to modernism in landscape we need to consider isolated examples. Steer, having gone through an 'impressionist' phase, at the turn of the century adopted a style which owed rather more to late Constable (*Plate 145*). Contemporarily, McTaggart's paintings (*Plate 146*) show what happens with an intelligent artist working inde-

pendently. He liked a light palette and his style may be characterized as that of the earlier Scots painter Thomson of Duddingstone adapted to a more impressionistic way of perceiving landscape. His work is often distinguished, and this scene of harvesters has an unsentimental directness not much seen in the Victorian era. J. D. Innes likewise turned to themes of perennial interest to landscape painters, his stylistic freedom giving them a refreshing directness (*Plate 148*), and the cumulative evidence is that independent artists could make of the old themes something less hackneyed than what Academy work allowed. This may be because they painted them because they wanted to, rather than in the pursuit of sure financial gain.

Those artists who reacted to modernism took landscape, as I implied above, only as a subject equal with any other. Painting in the 1900s and later did, however, produce some interesting work. Robert Bevan is famous for his love of horses, and took the chance of featuring

them in a scene of *Ploughing on the Aberdeen Downs* (*Plate 147*) in 1906-7. While the subject has many precedents, these are irrelevant to the dispassionate treatment of it as an exercise in divisionist technique. Likewise, Spencer Gore, portraying his fellow painter Harold Gilman's house at Letchworth (*Plate 151*) in 1912, a rather more urban scene, but at least one in a Garden City, was concerned with simplification of structure and colour and not with producing a composition that embodied visually what it was that was so good about life in these new developments, although the yearning for rural peace (the old myth, rural retirement) was one motive for

their construction. In the same year Duncan Grant painted his *Blue Sheep Screen* (*Plate 150*) and this consciously modernist work reduces the pastoral to a meaningless if attractive pattern on furniture. In terms of the trends that it has been fashionable to follow in the twentieth century, like abstraction or Surrealism, landscape is a minority concern, although it does have some interesting manifestations. Nicholson's paintings of the Cornish landscape (*Plate 149*) are as tasteful as any of his abstract paintings, while Ivon Hitchens does have an interest in landscape, which he marries with a broad and abstracted style (*Plates 152 a and b*). Neither of these painters

147
ROBERT BEVAN:
Ploughing on the Aberdeen Downs. 1906.
Oil on canvas.
Aberdeen Art Gallery and Museums

148
JAMES DICKSON INNES:
The Waterfall. 1911.
Oil on panel.
London, Tate Gallery

150 DUNCAN GRANT: *Blue Sheep Screen*. 1912. Oil on canvas. Private Collection

however has much connection with the traditions which have been discussed.

Other twentieth-century British painters do, and they do it in two ways. Firstly there are the straightforward landscapes, often of distinction, by painters like Sutherland or Paul Nash. And then there is a type of painting which betrays something like the concern with country life which we have detected in British landscape from the Restoration onwards. A good instance of a work of the first type is W. Nicholson's superb *Hill above Harlech (Plate 154)* of 1917, an image of a kind which recalls the painting of Hearne or Turner in the Lake District, but develops from it in its emphases on the patterns of fields in an olive-green landscape contrasted with the silvery blank of the sea and the smoky mountains. Equally, Stanley Spencer in works like *Cookham Moor (Plate 153)* portrayed an easily comprehensible 'village green' countryside, and although the artist was loath to do them, works like this sold. Equally one imagines that the erstwhile Vorticist Wadsworth had his pocket in mind when attempting to acclimatize the modernity of a new house through a tried compositional format (*Plate 155*).

Paul Nash and Graham Sutherland have both displayed a distinct interest in painting scenery, and have both evolved idiosyncratic visions for so doing. Nash began with a kind of cubist-derived format where all was simplified to angularity (*Plate 156*) and moved on to works which revealed the same preoccupations with relations of lines of wood to land, but after his flirtations with Surrealism (*Plate 157*) he allowed familiar objects, in this case a pillar, to be viewed from such angles that they assumed something beyond their mundane identity, and took on a slightly eerie character here boosted through the wan moon. Colour too is stylized. Nash employed a palette of greys and blues and the repetition of these hues through the landscape is an-

other factor in upsetting any altogether satisfactory pictorial logic. The painting works in terms of three-dimensional structure but the artist deliberately varied the balance of certain elements to create an element of tension. A careful selection of motifs to instil an element of ambivalence is noticeable throughout Nash's landscapes, but it would be wrong not to remark on those parts of his oeuvre where he seems to have done paintings of landscape simply because he liked what he saw (*Plate 158*).

Sutherland, too, is a distinguished artist (*Plates 159 and 160*). However, even though we know that he was obsessed with certain locales, in particular the landscapes of Pembrokeshire, there is no indication that his response to them was complicated by elements like the georgic or the pastoral. He wrote of Wales that 'The roads form strong and mysterious arabesques as they rise in terraces, hidden in sight', which, although the words 'strong' and 'mysterious' add atmosphere, is a plain description which communicates something of the artist's subjective response to what he has seen. There was a romantic element too. 'To see a solitary human figure descending such a road at the solemn moment of sunset is to realize the enveloping quality of the earth which can create, as it does here, a mysterious space limit, a womb-like enclosure'. He projects emotion onto the visited landscape, sees it in entirely subjective terms, counter, probably, to those of the inhabitants who would consider these paths inconvenient and the enveloping hills claustrophobic. Hence we cannot expect the paintings to have much concern with what we ourselves might see. Rather they make a pictorial approximation to this emotive response (unsurprisingly through oblique references to the works of Samuel Palmer). Sutherland's *Western Hills (Plate 159)* of 1938 stresses the bulging slopes and the anthropomorphic forms (which adds an interesting twist to the idea of getting

151
SPENCER GORE: *Harold Gilman's House at Letchworth*. 1912. Oil on canvas. Leicestershire Museums and Art Galleries

152a IVON HITCHENS: *Woodland, Vertical and Horizontal.* 1958. Oil on canvas. London, Tate Gallery

152b Detail of Plate 152a

153
STANLEY SPENCER:
Cookham Moor.
1937. Oil on
canvas. Manchester
City Art Galleries

154
WILLIAM NICHOLSON:
Hill above Harlech.
1917. Oil on canvas.
London, Tate Gallery

lost in landscape), with a palette of yel-
lows, greys, and pinks. In 1979 he was to
revert to this theme (*Plate 160*), using
similar colours and forms, fragmented
but still recognizable, making their re-
sonance through repetition.

For Sutherland landscape had per-
sonal and emotional meaning. To most
people now any response to place has to
be of the same order, at a time when the
landscape has never held so strong an
attraction. The attraction is odd because
the modern countryside is unsympathe-
tic, a fit companion to the modern city,
adapted to mechanized farming, with the
reality of the worker listening to the
radio in an air-conditioned tractor cab at
an enormous distance from the idea of
Hodge whistling behind his horses as
they draw his plough. The attraction of
rural retirement remains powerful, and
this was also the case at the end of the
nineteenth century.

155
EDWARD WADSWORTH:
Pen Pits. 1936. Oil on
canvas. Collection of
Lady Bliss

156
PAUL NASH: *Wood on
the Downs*. 1929. Oil
on canvas. Aberdeen
Art Gallery and
Museums

157
PAUL NASH: *Pillar and
Moon*. 1942. Oil on
canvas. London, Tate
Gallery

158
PAUL NASH: *Landscape
of the Malvern
Distance*. 1943. Oil on
cardboard.
Southampton Art
Gallery

There boiled up then a great reaction to towns, and this showed various symptoms. The first Town Planning Act of 1909 acknowledged that there was much wrong with the ways towns had developed. Prior to this was the important Garden Cities movement, gathering steam in the 1890s and under way at the turn of the century: we saw an example at Letchworth. The thinking was based on the premiss that if the new urban proletariat could be returned to the land and the old ways of craft and procedure, then the quality of life itself would climb back to some imaginary peak. This myth was doctrine with those middle-class people usually called the 'simple lifers', who wore a uniform of shapeless homewoven cloth and sandals. They included C. R. Ashbee, who in 1902 shipped the whole of his Guild of Handicraft from White-

chapel to the Cotswold town of Chipping Campden; a town which had decayed precisely through the social upheaval wrought in the countryside by the factories and urban development (at Birmingham), and to a lesser extent by the mechanization of farming. They had a certain naïveté. Fiona MacCarthy tells of the mathematician Harold Cox, who after a distinguished undergraduate career went to work as a farm labourer before starting a cooperative farm in Surrey. This produced only radishes, which were made into jam.

The country was thought to provide a morally healthier climate, and country life still to embody the 'true' values, a kind of thinking which appears to inform the paintings of George Clausen (*Plates 161 and 162*). Clausen was one of those Academic painters who were aware of

159
GRAHAM SUTHERLAND:
Western Hills. 1938.
Oil on canvas.
Scottish National
Gallery of Modern
Art

160
GRAHAM SUTHERLAND:
*Road at Porthclais
with Setting Sun*.
1979. Gouache on
masonite.
Haverfordwest,
Dyfed, Sutherland
Foundation

161
GEORGE CLAUSEN:
*Sheepfold in the
Evening.* 1890. Pastel.
The Fine Art Society
Ltd

some French developments. He had been impressed by the paintings of Bastien-Lepage and adapted the idiom of carefully painted *plein air* studies of labourers to the British scene. Later he turned to more generalized landscapes. Clausen's labourers recall Millet's but with none of the harshness: they are depicted with a sweetness which rings false against the documentation which is implied through their clothing and the sense of portrait in their faces. They work without complaint, and the more we study these images the less can we see that they were done at a time when the farm was becoming mechanized, the countryside changing quickly to become something very different to what it had been. There is a similar gap in credibility to the one found in the novels of Thomas Hardy, who found it hard to marry his desire for the pastoral with his knowledge of what country life was actually like. With most nineteenth- and twentieth-century painters and writers coming from towns a misinformed reaction is to be expected. And at the same time that element of appropriation of the

countryside, first noticed in respect of picturesque tourists, has grown. Since the middle of the nineteenth century the country has become available to all and offers its beauties willingly. We have come again to believe in the value of a country life and the worth of manual work on the land, ideas formulated in the later nineteenth century and of surprising persistence.

In the earlier 1910s Edward Thomas wrote about a short train stop in the Cotswolds, at a deserted station:

What I saw
Was Adelstrop — only the name

And willows, willow-herb, and grass,
And meadowsweet, and haycocks dry,
No whit less still and lonely fair
Than the high cloudlets in the sky.

It is a beautiful and evocative landscape, caught in a glimpse, and if that one image can lead to so much, how much better the real country life must be. This seeing of landscapes as caught images has been persistent this century. This is a passage from Philip Larkin's *Whitsun Weddings* (1964):

162
GEORGE CLAUSEN: *The
Boy and the Man.*
1908. Oil on canvas.
Bradford Art Galleries
and Museums

163
JAMES TUCKER: *Hiking*.
1936. Tempera on
wood. Laing Art
Gallery, Tyne and
Wear County Council
Museums

A slow and stopping curve southwards we
 kept,
Wide farms went by, short-shadowed cattle,
 and
Canals with floatings of industrial froth;
A hot house flashed, uniquely...

Both poets are sure of being understood,
the audience to whom their imagery will
be comprehensible is now extremely
large.

 Those who live in the towns and sub-
urbs understand perfectly how much
better it is to be in the country, and this
has been the case since the turn of the
century. Posters invoking the old myth,
retirement, were by the 1920s attemp-
ting to entice people from the towns. The
Hop Gardens of Kent (*Plate 165*) were
handy for the Londoner, while the Rail-
way company strove to seduce a similar
class of customer to the delights of its
camping coaches (*Plate 166*). These cus-

tomers were themselves identified in
paintings like Tucker's (*Plate 163*)
which showed them enjoying healthy ac-
tivity in the clean air, and the myth they
were chasing in photographs like
Malindine's of Tom Jones, the 'wonder
shepherd' (*Plate 164*), a species of rustic
superman with an almost uncanny ca-
pacity to communicate with his fine
Border collies. This was a man in har-
mony with nature, presented for the
delectation and wonderment of those
living in the town or suburbs in the era of
the Shell Guides, and the escape offered
through the motor car.

 The idea of the country as a preferable
alternative to the town is an ancient one,
and it is interesting to see how strongly it
has revived during this century. It is
hardly surprising that it also reflects in
the works of one or two painters. In his
etchings (*Plate 167*) John Nash did not
shy away from celebrating mechanized

164
EDWARD MALINDINE:
*Tom Jones, Wonder
Shepherd of Treorchy*.
1939. Photograph

THE HOP GARDENS OF KENT
BY MOTOR-BUS

GENERAL

WATERLOW & SONS LTD·LITH·LONDON·DUNSTABLE & WATFOI

farming, while C. Tunnicliffe, better known as an illustrator of birds, also produced fine prints (*Plate 168*) which reflect a traditional concern in the matter-of-fact recording of what goes on in the countryside at certain times of year. Both artists were unusual in being able to cope with mechanization, for often this seems to wreck the possibility of seeing the countryside in traditional terms, and this was probably to do with their both being countrymen, who understood what went on, and who were less emotionally antipathetic to the march of the machine. The other reaction can be seen in Vita Sackville-West's lines from a poem of 1942, where she described a tractor as:

This monster child of husbandry impure
Cuts four-fold wound regardless of the load,
Where once with single share the ploughman
 strode,
The farmer's reaction to this nostalgia would be mirth.

Gilbert Spencer has also kept to the old themes, and as a dispassionate observer has described aspects of modern rural life. His 1931 *Cotswold Farm* (*Plate 169*) is a straightforward survey of farm

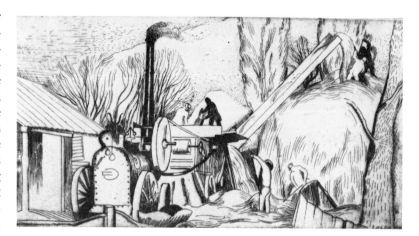

buildings with the winter shifting of timber, and does not bother with any message. David Jones (*Plate 172*) and James Bateman (*Plate 170*) have painted harvesting scenes which are modern variants of old themes. Jones's haymaking is a charming image, and while it is certainly stylized it nevertheless manages to report the procedure and is infused with the predominant green-brown of the cut grass. Bateman seems more intent on the myth that the 'real' Britain is to be found only in the country. The village, park,

167
JOHN NASH: *Threshing.* 1922. Etching. London, British Museum

168
CHARLES TUNNICLIFFE: *Mowing Bullock's Meadow.* Etching. Private Collection

169
GILBERT SPENCER: *Cotswold Farm.* 1931. Oil on canvas. London, Tate Gallery

170
JAMES BATEMAN: *The Harvest.* 1934. Oil on canvas. Collection — The Art Gallery of South Australia

and fields are washed in sunlight, while sail-reapers circumnavigate the cornfield, itself planted around a spinney, and there is a calm and placid feel to it all. There is no idea of tension, just rural pleasure, or so the artist would have us believe.

The great painter of the modern agricultural landscape was John Nash. He seldom populated his paintings because he was aware of the enormous modern decline in the number of men required actually to do the work, and he presents his scenes in a prosaic, matter-of-fact way. The famous *Cornfield* (*Plate 171*) abstracts the patterns formed by the lines of stooks and their relation to the wood and the lie of the land, but is still based on observation and knowledge of a landscape. Indeed, this quality of almost dryly showing what is there is noticeable in much of Nash's work, and his great

171
JOHN NASH: *The Cornfield*. 1918. Oil on canvas. London, Tate Gallery

172
DAVID JONES: *Mr Gill's Hay Harvest*. 1926. Pencil and watercolour. Private Collection

gift was to find an interest in most things, like the park scene at Glenham (*Plate 173*). The painting repays some study in detail. He has portrayed the lines of drying hay, the walls of the park, and its trees, the swell and slope of the landscape. In the foreground there is rusted barbed wire around a dead sapling. There is a strong feeling of this landscape having been deserted; the farmer now visits and exploits it rather than working in it.

The imagery of completed haymaking is one which has been illustrated several times through this book. Usually there is celebration and crowding — recall the lines of mowers and rakers in the Dixton haymaking. With Nash there is no longer any festive jollity. The pragmatic approach means that once the hay is dry enough it will be baled and carted off, and the lack of figures is a way of pointing up the peculiar quality of this modern development of a time-honoured motif.

John Nash's work has hardly been in any mainstream. He lived in the Stour Valley and his knowledge and understanding of the modern agricultural landscape has been unusually sympathetic. He is one of the few modern artists to

173
JOHN NASH: *Park Scene, Great Glenham.* Before 1943. Oil on canvas. Liverpool, Walker Art Gallery

174
VICTOR PASMORE: *The Park.* 1947. Oil on canvas. London, Private Collection

175a TOM PHILLIPS: *Benches*. 1970–1. Acrylic on canvas. London, Tate Gallery

175b Detail of Plate 175a

have drawn combine harvesters. One suspects that a craving for the simple country life is so selective an ideology that to acknowledge machines like this would disrupt the outlook beyond repair.

The impulse to get out of the city remains strong. The municipal park (*Plates 174 and 175a and b*) is a kind of staging post on the journey, offering urban residents the chance of space and vegetation within their own environment. The combination of images and legend in Phillips's *Benches* helps our understanding of the way these parks mediate between town and country. Once we have escaped, we have beer mats (*Plate 176*) with pictorial motifs (which we can associate with a long tradition) combined with a printed legend to remind us that we are fortunate to be in a country pub drinking natural beer, instead of in a chrome and plastic city one where everything is chemical. It does not, though, answer the question of why one is in a pub drinking when the purpose of getting out into the country is to commune with nature.

In the 1980s the old countryside, the one evolved in the eighteenth century, is disappearing. In East Anglia enclosure has vanished to recreate the open fields, the only ones practical for machines. Elsewhere arts like dry-stone walling and hedge-laying are dying out. This is in response to economic needs. The rural population stays in villages only if work is available in nearby towns, and even then the pressure is on, with townspeople, enraptured with the idea of a country life, forcing up the prices of village property to the extent that the locals can only stay local if there is adequate provision of council housing. Blake has given a view through the window of one of these cottages (*Plate 177*), one bought by middle-class people. Although this is a skilfully rendered image, it is of the same calibre and meaning as those images caught by Larkin and Thomas in their poetry, and there is a like sensation of the artist being transient in the environment.

The pastoral and the georgic always were part of the same myth, but their credibility was at least assured as long as

176
Greene King
Breweries: *Beermats.*
1980.

177
PETER BLAKE: *Butcher Cottage, Summer 1967*. Collection of Miriam Haworth

Butcher Cottage. Summer 1967. For Miriam, From Peter
Otto Plate

their poets and painters, their readers and patrons understood the reality behind them, and besides had a concern and interest in it. Today the countryside has become in a sense common property, an extension of the city, and so far no myth has been created to make it tolerable. With film and photography landscape painting has found powerful rivals, which it seems not yet able to vanquish.

List of Illustrations

Foundation. © Cosmopress, Geneva and A.D.A.G.P. Paris, 1981

161. GEORGE CLAUSEN: *Sheepfold in the Evening.* 1890. Pastel, 14¾ × 23½ (37.5 × 59.7 cm). The Fine Art Society Ltd

162. GEORGE CLAUSEN: *The Boy and the Man.* 1908. Oil on canvas, 77¾ × 64½ in (197.5 × 163.8 cm) Bradford Art Galleries and Museums

163. JAMES TUCKER: *Hiking.* 1936. Tempera on wood, 19¾ × 23⅝ in (50 × 60 cm). Laing Art Gallery, Tyne and Wear County Council Museums

164. EDWARD MALINDINE: *Tom Jones, Wonder Shepherd of Treorchy.* Photograph, published in *Illustrated,* 26 March, 1939

165. DOROTHY DIX: *The Hop Gardens of Kent by Motor-Bus.* 1923. Poster. London, Victoria and Albert Museum

166. FRANK NEWBOULD: *Camping Coaches in England and Scotland.* 1933. Poster for L.N.E.R. Crown copyright, National Railway Museum, York

167. JOHN NASH: *Threshing.* 1922. Etching. Reproduced by Courtesy of the Trustees of the British Museum

168. CHARLES TUNNICLIFFE: *Mowing Bullock's Meadow.* Etching. Private Collection

169. GILBERT SPENCER: *Cotswold Farm.* 1931. Oil on canvas, 55½ × 72½ in (141 × 184.3 cm).

London, The Tate Gallery

170. JAMES BATEMAN: *The Harvest.* 1934. Oil on canvas, 40 × 53½ in (101.6 × 136 cm). Collection — The Art Gallery of South Australia

171. JOHN NASH: *The Cornfield.* 1918. Oil on canvas, 27 × 30 in (68.6 × 76.2 cm). London, The Tate Gallery

172. DAVID JONES: *Mr Gill's Hay Harvest.* 1926. Pencil and watercolour 22½ × 15 in (57.2 × 38.1 cm). Private Collection. Photograph courtesy of Anthony D'Offay Gallery

173. JOHN NASH: *Park Scene, Great Glemham.* Before 1943. Oil on canvas, 24 × 30⅛ in (61 × 76.5 cm). Liverpool, The Walker Art Gallery

174. VICTOR PASMORE: *The Park.* 1947. Oil on canvas, 43 × 31 in (109.3 × 78.7 cm). London, Private Collection. Photograph courtesy of Marlborough Fine Art (London) Ltd

175a and b. TOM PHILLIPS: *Benches.* 1970-1. Acrylic on canvas, 48 × 108¾ in (121.9 × 276.2 cm); three canvases, each 48 × 36 in (121.9 × 91.4 cm). London, The Tate Gallery

176. Greene King Breweries: *Beermats.* 1980

177. PETER BLAKE: *Butcher Cóttage, Summer* 1967. Watercolour, 9 × 16 in (23 × 40.5 cm). Collection of Miriam Haworth

Tailpiece: THOMAS GAINSBOROUGH: *Study of a Cow. c.* 1755-7. Pencil on brown-toned paper, 6 × 7½ in (15.2 × 19 cm). London, Private Collection

Bibliography

Few books deal with British landscape painting in general. They tend either to be histories of particular periods, or monographs on individual artists. The list below is meant as a guide to literature, not exclusively on painting, but on various other approaches to landscape.

J.R. Abbey, *Scenery of Great Britain and Ireland 1770-1860*, London 1952

J. Barrell, *The Idea of Landscape and the Sense of Place*, Cambridge 1972
The Dark Side of the Landscape, Cambridge 1980

M. Girouard, *Life in the English Country House*, New Haven and London 1978

A. Greutzner, 'Great Britain and Ireland' in *Post-Impressionism*, Royal Academy of Arts, London 1979-80

M. Hardie, *Water-Colour painting in Britain*, 3 vols, London 1966-8

J. Harris, *The Artist and the Country House*, London 1979

L. Herrmann, *British Landscape Painting of the 18th Century*, London 1973

C. Hussey, *The Picturesque*, London 1967
English Gardens and Landscapes 1700-1750, London 1967

E. Malins, *English Landscaping and Literature 1660-1840*, London 1966

H.V.S. and M.S. Ogden, *English Taste in Landscape in the Seventeenth Century*, Ann Arbor 1955

L. Parris, *Landscape in Britain c. 1750-1850*, London (Tate Gallery) 1973

J. Rothenstein, *Modern English Painters*, 3 vols, London 1976

R. Shone, *The Century of Change: British*

A. Staley, *The Pre-Raphaelite Landscape*, London 1973

R. Treble, *Great Victorian Pictures, their Paths to Fame*, London, Arts Council 1977

E.K. Waterhouse, *Painting in Britain 1530-1790*, London 1953

J.R. Watson, *Picturesque Landscape and English Romantic Poetry*, London 1970

C. White, *English Landscape 1630-1850*, New Haven 1977

R. Williams, *The Country and the City*, various editions

A. Wilton, *British Watercolours 1750 to 1850*, Oxford 1977

Index